IMAGES
of America

LYNCHBURG
1757–2007

IMAGES
of America

LYNCHBURG
1757–2007

Dorothy and Clifton Potter

ARCADIA
PUBLISHING

Published by Arcadia Publishing
Charleston SC, Chicago IL, Portsmouth NH, San Francisco CA

Printed in the United States of America

Library of Congress Catalog Card Number: 2006934432

For all general information contact Arcadia Publishing at:
Telephone 843-853-2070
Fax 843-853-0044
E-mail sales@arcadiapublishing.com
For customer service and orders:
Toll-Free 1-888-313-2665

Visit us on the Internet at www.arcadiapublishing.com

This slim volume is dedicated to all of the men and women who have created, captured, and preserved images of Lynchburg—her people, her buildings, and every aspect of the life of the City of Seven Hills from 1757 to the dawn of 2007. Worthy of special mention are Adam Plecker, who recorded the city's rapid development in the years between the Civil War and the end of World War I, and Nancy Blackwell Marion, whose digital archive is saving Lynchburg's visual past for another century. State-of-the-art technology makes it possible for her to restore faded images from the past to their original clarity. If a picture is indeed worth 1,000 words, then thanks to Ms. Marion, Lynchburg is richer by many millions.

CONTENTS

ACKNOWLEDGMENTS

Many people and organizations in Lynchburg have made writing this book a pleasure. Jones Memorial Library is always an essential research site; its staff, particularly Lewis Averett, Wayne Rhodes, and Nancy Wieland, have been invaluable. The staff of the Knight Memorial Library at Lynchburg College has also been very helpful.

Nancy Blackwell Marion of the Design Group has shared numerous images from her unique electronic catalog of the city's people and structures. The Southern Memorial Association, particularly Jane White and Ted Delaney, provided remarkable images and insights about the Old City Cemetery. The *Lynchburg News* also provided several images from their archives. Postcards from Dr. Robert Gardner, "Dr. Nostalgia," form a significant portion of the 19th and early–20th century Lynchburg scenes.

Thanks are due to Thomas Jefferson's Poplar Forest, particularly Octavia Starbuck for her support. Greg Starbuck, the director of Historic Sandusky, provided images and expertise on the battle of Lynchburg. Michael V. Taylor at the Hampton Roads Naval Museum was invaluable to our research on medals awarded during the Jamestown Exposition of 1907.

The following people or organizations allowed us reproduce pictures from their collection, permitted us to take pictures, or took photographs for us: Meg Carrington; Michael Creed; Dr. James D. Cure; Dr. Roland and Lorri Girling; Danny Goodman; Pete Graves; John P. Hughes III; Ann P. Hicks and Randy Lichtenberger of the Friends of New London, Virginia, Inc.; the Lynchburg Foundry; and Randolph-Macon Woman's College.

Ronnie Tucker provided his photographic expertise and several unique images, including our cover photograph. Without the tireless efforts of Mike Johnston in Lynchburg College's Information Technology and Resources Center, this book would not have been possible.

We would also like to acknowledge the support of our colleagues at Lynchburg College, especially Dr. James L. Owens, chair of the history program. Our son Edmund Potter, curator at the Woodrow Wilson Presidential Library at his birthplace in Staunton, Virginia, obtained a Jamestown medal and provided his photographic expertise.

Lastly, we owe a great debt to our editor at Arcadia Publishing, Courtney Hutton, for her advice, patience, and understanding.

Please note that in cases where an image does not contain a courtesy, the photograph was taken by the authors.

INTRODUCTION

Lynchburg owes its mid-18th-century beginnings to an auspicious combination of environment, a cash crop that enjoyed world-wide demand, faith, and the fortunes of war. Like many communities throughout history, it was founded on a river system. The James is Virginia's primary river. Long before the advent of the first permanent English settlement at Jamestown in 1607, it provided food, transportation, and occasional protection for the Native American tribes negotiating its waters.

For many years, the James River was crucial to Lynchburg's survival. White settlers found that rivers could more easily be traversed than the primitive dirt roads that crisscrossed antebellum Virginia. The James provided Lynchburgers with water for drinking, cooking, bathing, and baptisms. Until the arrival of a canal in 1840 and the railroad in 1852, it was the means of sending the area's tobacco and corn to Richmond and bringing back specialty goods from the more urbane Tidewater to the frontier town near the Blue Ridge Mountains.

The James can, however, be a cruel and capricious river. In hot, dry summers, the broad rocks strewn about its bed lure the unwary to walk across it; some do so to their peril. With heavy rains or tropical storms, it springs to life, bursting its banks with alarming speed and carrying all before it. Lynchburg experienced devastating floods in 1870, 1877, 1913, and 1969; during the "100-year flood" of 1985, the mighty James nearly reached the roadway on the Williams Viaduct.

The Lynch brothers built their ferry service, and eventually a town, on their ability to get travelers safely across the James. There was a ready market for their services, as at the onset of the French and Indian War in 1756, settlers began to move westward, looking for new sites to plant tobacco.

Tobacco became Central Virginia's primary crop and was responsible for many Lynchburg fortunes. Those men who owned large estates or tobacco processing factories found its nickname "the Golden Leaf" entirely fitting. Among these early farmers were the Quakers, or "Friends," whose strict interpretation of Christianity did not preclude making money through agriculture.

The Friends were vital in establishing Lynchburg's strong tradition of faith. Led by Sarah Clark Lynch and most of her family, they established the South River Meeting in 1757. The Friends were joined in time by Methodists, Baptists, Presbyterians, and other denominations. Ironically, these town members foremost in establishing the community became, as a group, the first to leave it. Tobacco culture had become increasingly dependent on slave labor, an unacceptable practice to the Friends. Before Lynchburg passed the century mark, local Quakers had either emigrated westward or given up their faith.

By 1855, thanks to tobacco, Lynchburg was reputed to be the second wealthiest city in the United States. That same year it opened a new cemetery, completed its courthouse, and welcomed a college. The converse to this bright economic picture was the city's African American community. Though they made up approximately 40 percent of the population, they had little share in the city's prosperity; only about 7 percent were free.

When secession was proposed in April 1861, the city rejected it; war was after all bad for business. Once Virginia joined the other Confederate states, however, Lynchburg supported the war both materially and emotionally. Families sent husbands, sons, or fathers to the conflict, many not returning. The city's centrality and three railroads made it a logical hospital center, as well as a short-term prison camp for captured Union soldiers. Despite the tragedy of war, Lynchburg did not suffer the deprivations of many Southern cities. The battle that ensued near the ruined Quaker meetinghouse on June 17–18, 1864, was relatively minor. While the railroads, river, and canal led to an influx of wounded and dying soldiers from both sides, the same transport systems ensured the city would not be isolated or reduced to starvation. Gen. Robert E. Lee's surrender at Appomattox on April 9, 1865, saved Lynchburg, his intended destination, from becoming a potential battle ground.

Peace brought reconstruction, literally and politically, and Lynchburg's recovery was rapid. The 1880 invention of the cigarette rolling machine and gradual shift of the tobacco markets southward fostered a more diverse economy. The city remained a vital rail center and by the late 19th century was notable for dry goods, furniture, shoes, wagons, and a growing number of colleges. At the start of the 20th century, higher education was still largely the purview of white males, but by 1903, coeducation was part of the systems of Virginia Seminary and College and Virginia Christian College (the former for blacks, the latter for whites). Randolph-Macon Woman's College and Sweet Briar College provided single-sex academic experiences.

The 20th century also brought the renewed specter of war. Lynchburgers, like their fellow citizens throughout the nation, served their country in various ways. Their service is commemorated at the city's signature landmark, Monument Terrace. From the World War I doughboy at its base, up stairs and landings where the dead of the Spanish-American War, World War II, Korea, and Vietnam are honored, to the Civil War soldier and 1855 courthouse that crests the hill, Monument Terrace is a source of architectural pride and a gathering place for veterans and other groups. It is also featured on the reverse of a commemorative half-dollar issued in 1936 to recognize Lynchburg's sesquicentennial. Among Virginia cities, only Norfolk has been similarly honored. The coin's obverse shows Sen. Carter Glass, father of the Federal Reserve System.

As the century continued, other institutions of higher learning, including Central Virginia Community College, Liberty University, and Christ College, found homes in Lynchburg. Founded by the notable pastor Jerry Falwell, Liberty University continues to grow in size and reputation. As the city advances into the 21st century, its prominence as a college and university town has become one of its most important assets.

Tourism is another area of great economic potential to Lynchburg. In addition to a revitalized riverfront, six historical districts, an annual Kaleidoscope festival, the Virginia Ten Miler, the Virginia School of the Arts, the Children's Museum, the Academy of Fine Arts, other civic attractions, the proximity of Thomas Jefferson's Poplar Forest, the Appomattox surrender grounds, and Smith Mountain Lake offer historical and recreational opportunities.

Over the course of 250 years, Lynchburg has acquired many nicknames. Five of these have introduced the chapters in this book. They offer a sketch of what Lynchburg has been about. They are not necessarily permanent, and some are no longer accurate. The descriptive "Seat of Satan's Kingdom" was a phrase that itinerant Methodist preacher Lorenzo Dow imposed on more than one preaching site. "Tobacco Town" no longer describes the city's economic life; and as anyone acquainted with the area knows, there are more than seven hills in Lynchburg. However "City of Churches" remains apt, as does the potential for Lynchburg's continued growth as a "Seat of Learning." As Lynchburg anticipates its role as an historic quadricentennial community in 2007, its future looks bright indeed.

One

THE SEAT OF
SATAN'S KINGDOM
1757–1806

Central Virginia was first home to the Monacans. Centuries before Thomas Jefferson described Natural Bridge in his *Notes on the State of Virginia* (1787), Native Americans traversed it pursuing deer, bear, or buffalo. Currently Monacans demonstrate aspects of traditional Native American life for visitors in a recreated setting at Natural Bridge.

Lynchburg's history has long been bound to the river named for James I, England's and Scotland's king in 1607. John Lynch, the son of a Quaker widow, and his brothers established a ferry service in 1757 and soon added a tavern to accommodate travelers. Add to this the westward expansion due to tobacco cultivation, and by 1786, there were enough Quakers and other settlers to establish a town. Virginia's General Assembly authorized John and Charles Lynch and nine associates to sell lots and create streets. While early houses were modest, Lynch's Mill and several tobacco warehouses were more substantial.

A growing town required public buildings; by 1794, Lynchburg had the Mason's Hall, serving not only Freemasons but also as a courthouse, school, voting site, and worship space. The Quaker meetinghouse was in use by 1798, but was outside the town limits. Early 19th-century itinerant preachers noted that within the town were plenty of taverns, stables, and stores but no churches. The fiery evangelist Lorenzo Dow called Lynchburg "the Seat of Satan's Kingdom." Local Methodists finally constructed a church in 1806, in an area that would be called Church Street.

By 1800, Lynchburg had nearly 500 residents, a weekly newspaper, and by 1806, a public burying ground just outside its boundaries. Increased commerce on the river added to its growing prosperity. Flat-bottomed boats called bateaux, which carried tobacco and other goods to Richmond in about a week and returned within 10 days, linked Lynchburg to the rest of Virginia.

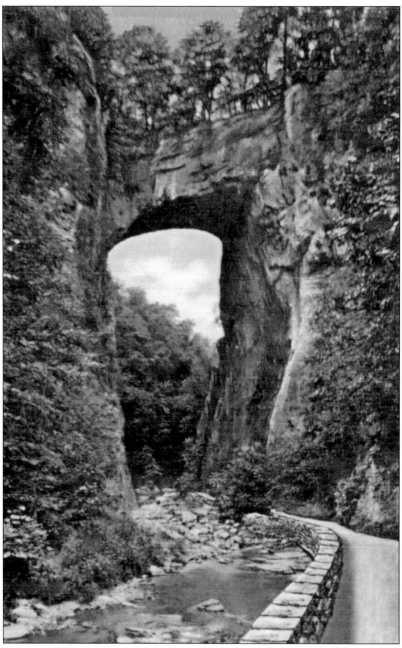

To the northwest of Lynchburg in Rockbridge County stands the Natural Bridge. Surveyed by George Washington and once owned by Thomas Jefferson, for over a century it has been one of the most popular tourist destinations in Central Virginia. Today the Monacan tribe has recreated a small Native American village just beyond the Natural Bridge. When the Lynch family first settled on the banks of the James River—then called the Fluvanna—the Monacans hunted under the shadow of the bridge. Long the victims of discrimination, the Monacans now are one of the eight tribes recognized by the State of Virginia and are currently seeking federal recognition. In 2006, representatives of the British government received Monacan leaders. (Courtesy of the Potter Collection.)

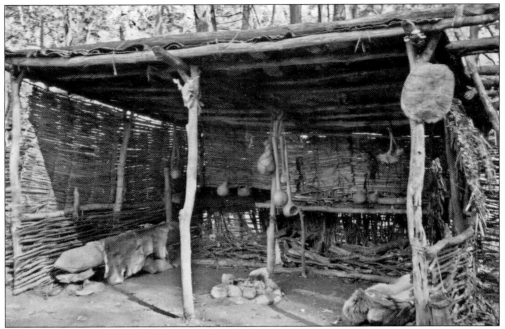

The carefully reconstructed lean-to at the Monacan village at Natural Bridge contains the supplies needed to sustain members of the tribe. These silent witnesses of the past are vital elements in the educational mission of the tribe. The Monacans seek to preserve the wisdom and folkways of their ancestors, enriching the lives of their children and all Virginians.

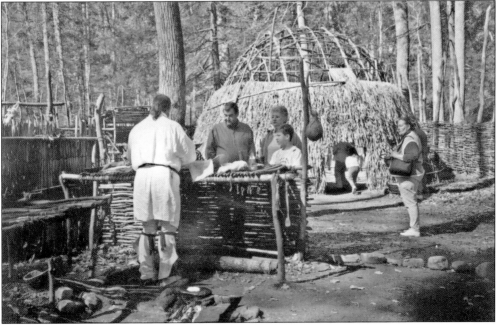

Chief Kenneth Branham of the Monacan tribe demonstrates cooking techniques to visitors to the model village. Behind them stands a partially completed dwelling. Although substantial, it could be easily disassembled and moved. The hills above the James River were dotted with similar structures long before trappers penetrated the Virginia wilderness.

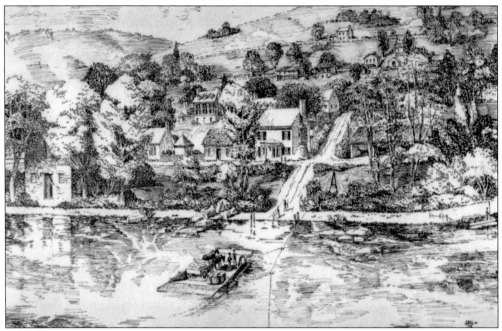

No photograph of the Ferry House at its original location survives, but this modern sketch by John P. Hughes III places it amid the other buildings clustered on the edge of the James River during the American Revolution. It served a number of purposes before being moved and becoming a private residence. Its last remnants vanished in the 1920s. (Courtesy of Jones Memorial Library.)

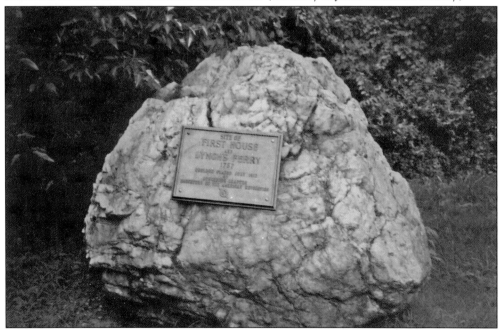

The Ferry House was moved in the 1840s, but it was removed in the early 20th century in the name of progress. In 1913, the Daughters of the American Revolution (DAR) marked the spot where Lynchburg was born with a bronze plaque mounted on a huge boulder. The Norfolk and Western Railway moved it in 1913 because it was in the way of all forms of traffic.

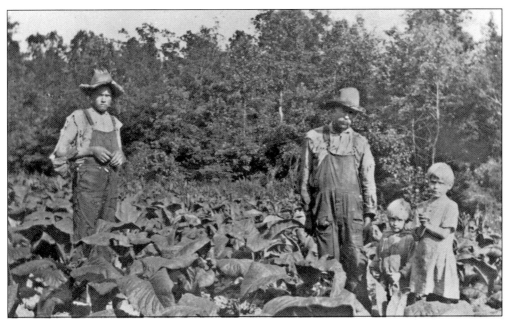

Tobacco saved Virginia and made Lynchburg's fortune, and the Quakers were the forerunners of its development. Like Jamestown, it was their sovereign remedy. Well into the 20th century, as this photograph of the Goodman family shows, it was cultivated just it had been when Lynchburg was a fledgling town. (Courtesy of Danny Goodman.)

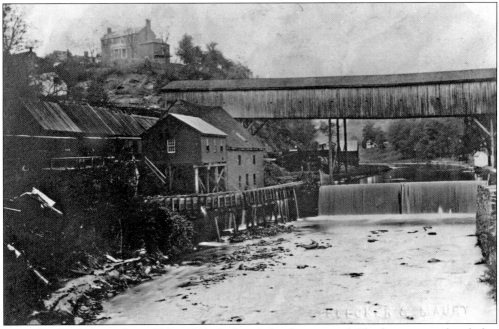

As settlers headed west from 1756 to 1763, the Lynch family prospered. The frontier was closed after the French and Indian War; thus until the American Revolution, many settled on lots purchased from John Lynch. Soon he built a warehouse and a mill. This 19th-century photograph shows the vanished Lynch's Mill, the Virginia and Tennessee Railroad covered bridge, and the Cabell mansion. (Courtesy of Jones Memorial Library.)

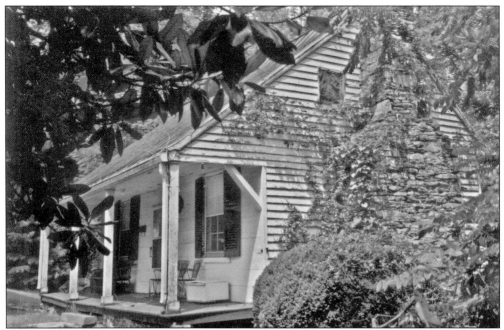

Built in 1767 and located near the reconstructed Graves Mill, the Christopher Johnson or Miller's Cottage on Old Graves Mill Road is the oldest, still-occupied domestic structure within the city limits. This modest house is typical of the type of dwelling favored by the members of the South River Meeting. It remains virtually unchanged today.

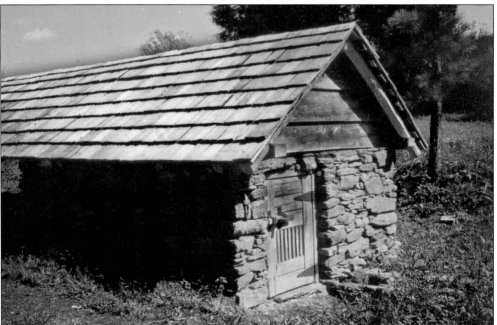

Dr. Rowland and Lorri Girling have restored the springhouse, one of the dependencies on their farm, Speed the Plough, near the village of Elon in Amherst County. Built c. 1780, it is typical of similar structures that might have been found in Lynchburg before 1860. To celebrate Virginia's Quadricentennial, the Blue Ridge Chapter of the DAR will landscape the area.

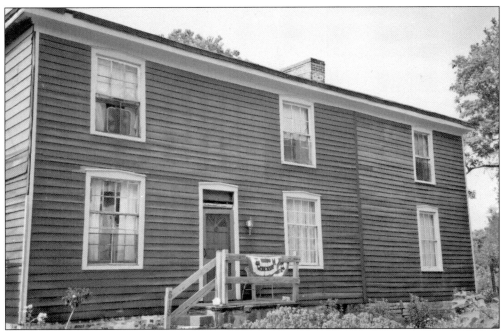

At the corner of First and Harrison Streets stands the oldest extant domestic dwelling within the original corporate limits. Built by John Lynch for his eldest daughter, Matilda, its location was ideal, giving easy access to the growing town. Completed in 1787, it has been used for a number of purposes; today it is again a home.

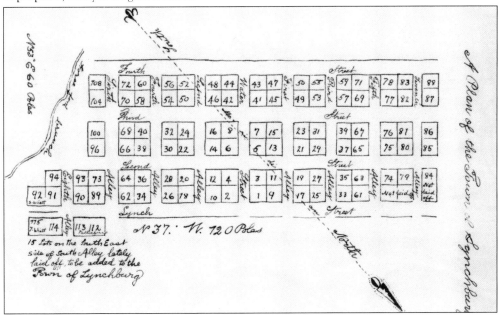

Drawn in 1790, Richard Stith's detailed plan of Lynchburg demonstrates the Lynch family's success in attracting settlers to their growing town. Stith began surveying the town in 1787 and completed his work in 1790. Incorporation by the General Assembly of Virginia four years earlier had created an independent political entity from land formerly part of Campbell County. (Courtesy of Jones Memorial Library.)

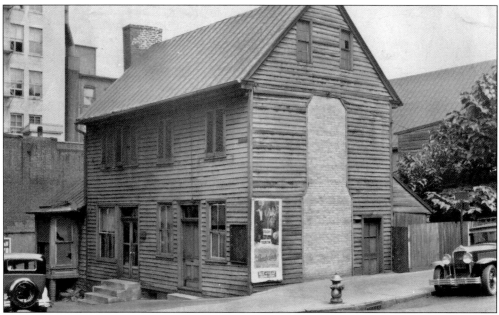

From 1791 until 1936, when it was moved to Riverside Park, the Miller-Claytor House stood on the corner of Eighth and Church Streets. A beautifully preserved, late-18th-century townhouse, it might have been demolished had it not been for the Lynchburg Historical Society. They purchased and reconstructed it on the edge of the park as a sesquicentennial project. (Courtesy of Jones Memorial Library.)

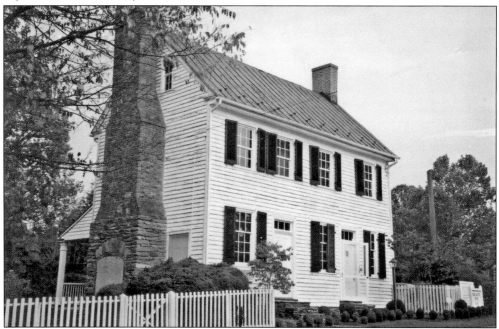

The restored house has stood beside an entrance to Riverside Park for two generations. Countless school children have visited this relic of Lynchburg's past and wandered through its lovely period garden. In 2003, it was appropriately the beginning point of the first annual Ghost Walk, sponsored by the Lynchburg Historical Foundation.

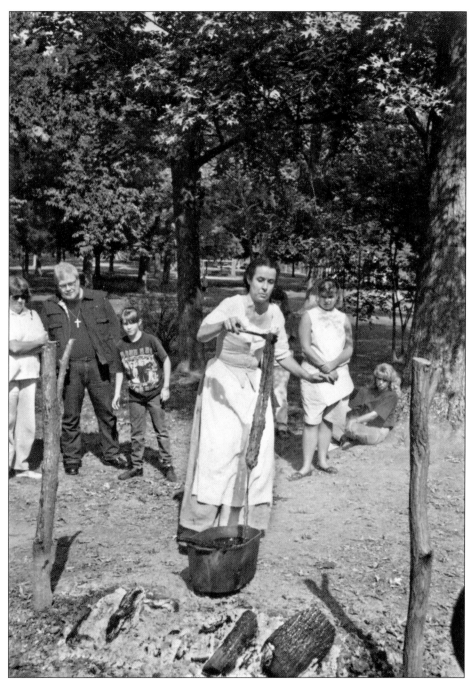

Over the years, the gardens and environs of the Miller-Claytor House have provided a venue for events and presentations related to the fascinating history of Lynchburg. This photograph, taken during the 1990 Kaleidoscope Festival, shows a demonstration by Dr. Leni Sorensen, noted authority on African American social history, of 18th-century techniques for dying yarn with indigo. Until the Revolution, the American Colonies had an imperial monopoly on indigo cultivation. It was used to dye material for servants' clothing, and after 1776, the uniforms of the newly created American Army.

Built at the corner of Twelfth and Commerce Streets in 1791, the second oldest tobacco warehouse in Lynchburg illustrates the typical configuration of such structures. They were unadorned, designed for the storage and sale of tobacco. As Lynchburg's tobacco trade changed with the invention of the cigarette-rolling machine, tobacco warehouses were converted to other uses and eventually demolished, their bricks and beams recycled. (Courtesy of Jones Memorial Library.)

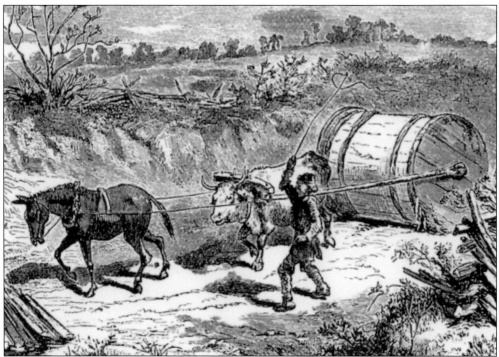

Tobacco in Virginia has been packed in an ingenious contraption called a "hog's head," resembling a giant oak barrel, since its earliest days of cultivation. Once it was tightly packed with tobacco, the axle that ran the length of the hog's head was attached to a yoke of oxen or a team of mules, creating a giant wheel. (Edward King, *The Great South*, 1875.)

Marshall Lodge No. 39 Ancient Free and Accepted Masons was founded in 1793. The first lodge, built in 1794–1795, was located on the north corner of Ninth and Church Streets and also served as the town's courthouse, a schoolhouse, and the meeting place for several congregations. Replaced in the 1840s, the 1794 structure was moved to Fifth Street, becoming a home until it was demolished in 1921. (Courtesy of Jones Memorial Library.)

Lynchburg and Farmer's Gazette.

[Number 7 of Vol. II.] SATURDAY APRIL 5, 1794. [At Fifteen Shillings per Annum.]

LYNCHBURG: PRINTED BY ROBERT MOSEY BRANSFORD, WHERE ESSAYS, ARTICLES OF INTELLIGENCE, ADVERTISEMENTS, &c. ARE THANKFULLY RECEIVED, AND ALL KINDS OF PRINTING PERFORMED WITH ELEGANCE AND DISPATCH.

The first newspaper to appear in the town of Lynchburg was the weekly *Lynchburg and Farmer's Gazette*. This edition from Saturday April 5, 1794, contained advertisements and local news, but most of its four pages were filled with stories gleaned from other publications. Before the invention of the telegraph, small, locally produced newspapers were the only links between frontier settlements and the wider world. (Courtesy of Jones Memorial Library.)

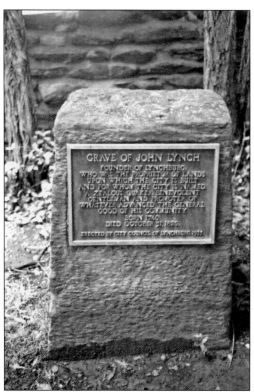

This monument stands in the Quaker Cemetery: "Grave of John Lynch—Founder of Lynchburg who was the proprietor of lands upon which the city is built and for whom the city is named. A zealous Quaker, benevolent gentleman and promoter of whatever advanced the general good of his community. Born 1740. Died October 31, 1820. Erected by the City Council of Lynchburg, 1935."

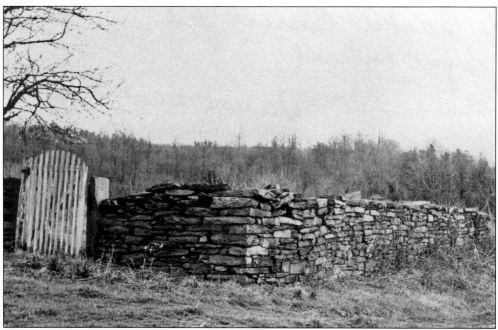

In the 19th century, a road separated the South River Meeting House from the burying ground, a Quaker resting place surrounded by a wall of fieldstones and secured by wooden gate. After the Battle of Lynchburg in June 1864, a number of Union soldiers were buried both inside and outside the walls of the cemetery in shallow, unmarked graves. (Courtesy of Jones Memorial Library.)

The meetinghouse was abandoned in the 1840s as the number of Quakers in Lynchburg declined because they did not condone, nor could they compete with, slavery. By the early 1860s, the meetinghouse was in ruins. In the 20th century, it was restored by the congregation of Quaker Memorial Presbyterian Church. They still maintain both the meetinghouse and the adjacent cemetery, preserving the heritage of Lynchburg's pioneer Quakers.

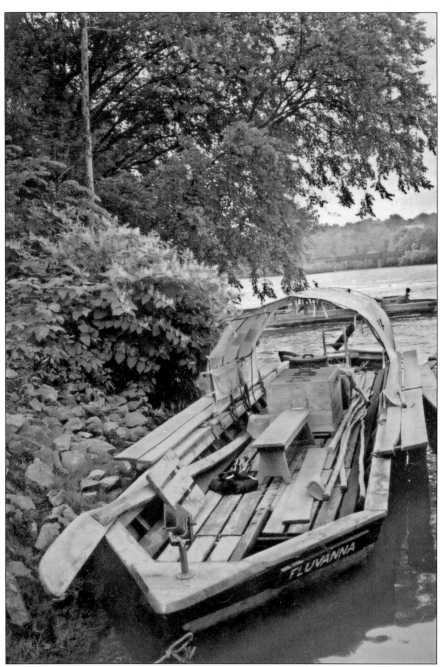

Before the Kanawah Canal and the railroads, there were the bateaux. These shallow, flat-bottomed boats were perfect for hauling goods from Lynchburg to Richmond. They were as famous as the Dutch fly boats of the 17th century. Under the skilled management of a generation of African American bateauxmen, these craft could easily negotiate the treacherous currents of the James River, taking nearly a week to reach Richmond and 10 days to return. The men who guided these vessels were slaves, but on the river they enjoyed freedom denied to them on shore. Laws were passed to govern their behavior, but these were mostly ignored. The *Fluvanna* is a replica of these historic boats that vanished after 1840, when the Kanawah Canal reached Lynchburg.

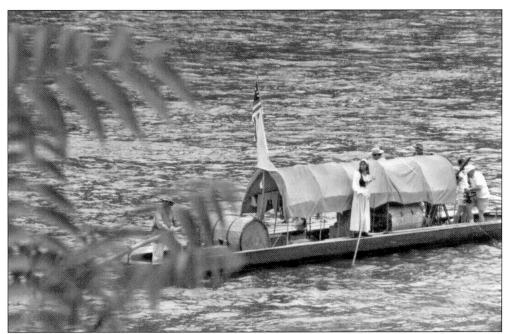

Each June since 1985, crews have made the long journey to Richmond's outskirts in reproductions of the original bateaux. These modern craft are based on the remains of a bateau found in the mud of the James River near Richmond. The bateaux race has slowly blended with Civil War Days to create a festival that draws ever-increasing crowds to Lynchburg's riverfront.

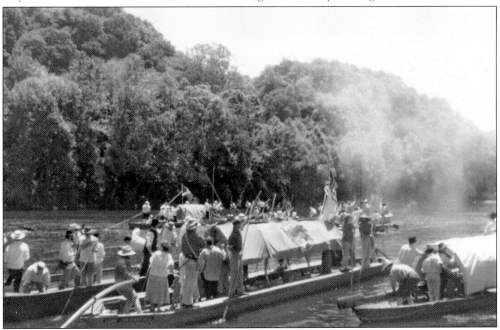

The bateaux race marks the beginning of summer for many in Lynchburg and the counties through which the river flows. Each night, the crews pull into shore for an evening of period food, songs, and stories. Local residents are welcomed, as the present is forgotten and the early 19th century lives again.

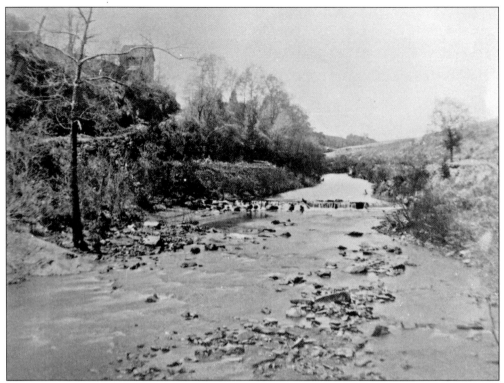

Blackwater Creek is the most important tributary of the James River in Lynchburg. Businesses were founded and flourished on its banks in the town's early years. Unfortunately, a century ago it was almost an open sewer. Now it is the central focus of the nature preserve that forms the wooded heart of modern Lynchburg. (Courtesy of Jones Memorial Library.)

In March 1806, John Lynch donated an acre of land on Lynchburg's outskirts for the first public "burying ground." The resting place of the rich and poor, slave and free, the Old City Cemetery remains a silent witness to Lynchburg's history. The cemetery is under the care of the Southern Memorial Association, which has transformed it into one of Lynchburg's loveliest spots.

Two

THE TOBACCO TOWN
1807–1856

During the first half of the 1800s, Lynchburg evolved from a frontier town to the fastest growing city west of Richmond. Elegant homes and public buildings were built, wealth increased, and life became substantially more urbane.

For decades, until his death in 1826, Lynchburg took pride in the proximity of Thomas Jefferson, who on retirement spent more time at his nearby retreat, Poplar Forest. In various letters to friends, Jefferson approvingly noted the town's economic potential; local citizens reciprocated with affection and respect for their distinguished neighbor. A favorite story described how the former president taught Lynchburgers to eat tomatoes by consuming a reputedly poisonous "love apple" in the Miller-Claytor House garden. A connoisseur of good food and wine, Jefferson advised the owner of the Franklin Hotel, an establishment built where Methodist preacher Lorenzo Dow had formerly enumerated Lynchburg's sins.

Slavery was the tragic negative to this growing prosperity. Lynchburg had more free African Americans than any other Virginia city, a final legacy of its Quakers, who had left the area by the 1840s. But as its tobacco warehouses, factories, and other businesses increased, so did their enslaved laborers. Death was also an ever-present reality. No class or race was spared diseases like smallpox, tuberculosis, and yellow fever. Faced with an often-uncertain future, Lynchburgers sought spiritual and physical relief in various ways. Taverns proliferated, but so did churches, Protestant, Catholic, and Universalist. For those who could afford it, there were three local mineral springs where patrons could bathe in supposedly healing waters.

By the mid-19th century, Lynchburg had both a female seminary and a college, although each was a private institution for the wealthy. One could enter or leave the city by canal boat, stagecoach, or locomotive. Visitors like Anne Royall praised Lynchburg's beautiful scenery, and artists Henry Howe and Edward Beyer included it in their depictions of noted Virginia locales. The 1850s were for many the best of times, but war would change that.

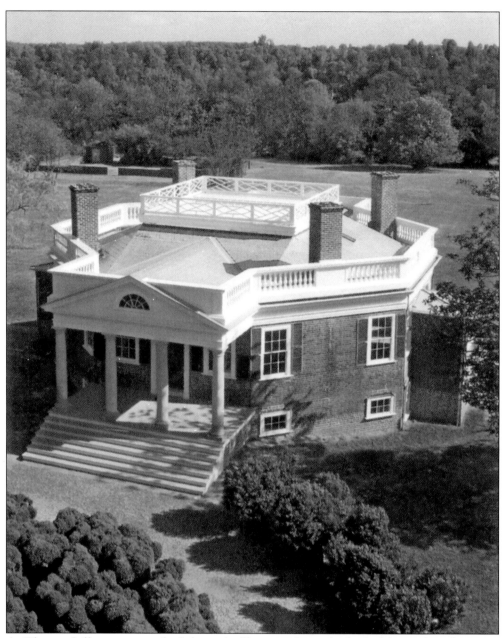

As Thomas Jefferson approached the end of his presidency, he looked forward to the peace and solitude that life in the country provides. Unfortunately, that tranquility was missing at his Charlottesville mansion, Monticello. He was constantly bedeviled by office seekers and the curious. In 1806, he laid the foundation of his country retreat, Poplar Forest, not far from Lynchburg. This remarkable house, in which all his architectural ideas met in perfect harmony, furnished the solace that he craved. The farm that surrounded it also provided a large part of the revenue that financed the projects that consumed the last years of his life. Poplar Forest's remote setting in Bedford County meant that Jefferson could select the guests he wished to entertain. Construction on the house continued until 1819; he died in 1826. (Photograph by Les Schofer, courtesy of Thomas Jefferson's Poplar Forest.)

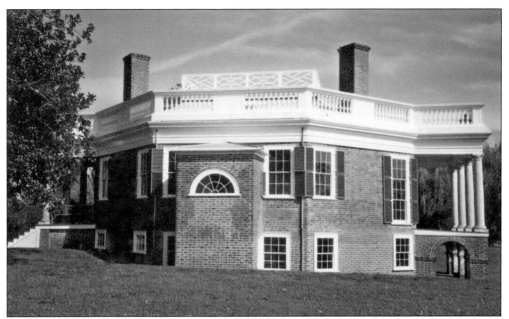

This side view of Poplar Forest demonstrates Jefferson's fascination with the octagon as an architectural form. In the center of the house is a room that is a perfect cube, lit by a cleverly designed skylight. Each of the windows provided Jefferson with a different view of the rolling country and mountains of Central Virginia. (Photograph by Dorothy Potter, courtesy of Thomas Jefferson's Poplar Forest.)

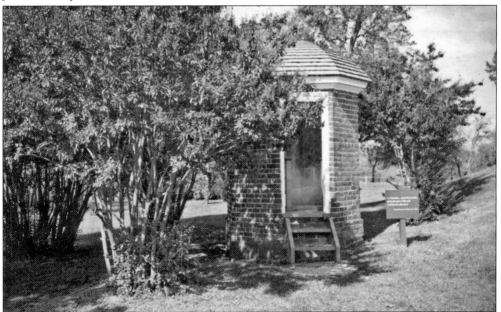

For Jefferson, no structure, however humble, was ignored, added as an afterthought, or devoid of that symmetry and beauty which were the hallmarks of his designs. This octagonal "necessary" or privy was an essential part of Jefferson's overall design of Poplar Forest. These indispensable buildings were usually hidden in the rear of a garden, concealed by shrubbery. (Photograph by Dorothy Potter, courtesy of Thomas Jefferson's Poplar Forest.)

Before the Lynch family gave land for the Old City Cemetery, there was an Episcopal burying ground bordered by Tenth, Eleventh, Court, and Clay Streets. After the Anglican Chapel burned in 1802, the site was abandoned and some bodies were moved to the new cemetery, including John Brown, who died in 1801. His stone is perhaps the only extant monument from that long-forgotten churchyard. (Courtesy of the Southern Memorial Association.)

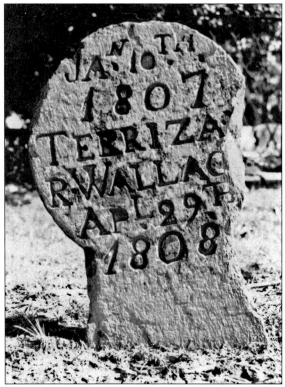

Born in January 1807, Terriza R. Wallace died in April 1808. Many children did not survive infancy in the early 1800s, often succumbing to diseases that are routinely prevented two centuries later. The cause of death of the Wallace infant is unknown, but her primitive stone is the oldest surviving monument of those persons who were buried in the Old City Cemetery. (Courtesy of the Southern Memorial Association.)

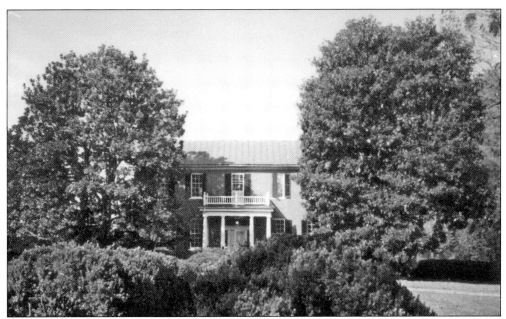

Around 1808, Charles Johnson built a house a few miles from Lynchburg. In 1790 in Kentucky, he was captured by Shawnee Indians and released in Ohio. Johnson named his home Sandusky, to recall his place of deliverance. The house was purchased by the Hutter family and was commandeered by Gen. David Hunter as his headquarters during the Battle of Lynchburg in June 1864. (Photograph by Dorothy Potter, courtesy of Historic Sandusky.)

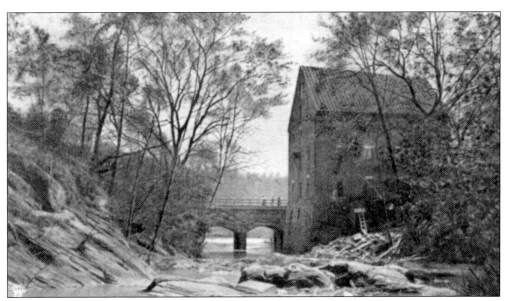

When Galt's Mill was built on the James River in Amherst County in 1813, about 13 miles from Lynchburg, it was one of many mills that ground the corn and grain harvested in the counties that surrounded the town. First in the bateaux, then on canal boats, and finally by rail, meal and flour from Central Virginia were shipped all over the region. (Courtesy of the Potter Collection.)

There has been a public market in Lynchburg almost from the day the Lynch brothers began to ferry pioneers across the James River, but by the 1850s, the 1814 Market House in the middle of Ninth Street between Main and Court Streets was a public eyesore and a gathering place for stray dogs that fed upon garbage discarded by vendors. It was finally demolished in 1873. (Courtesy of Meg Carrrington.)

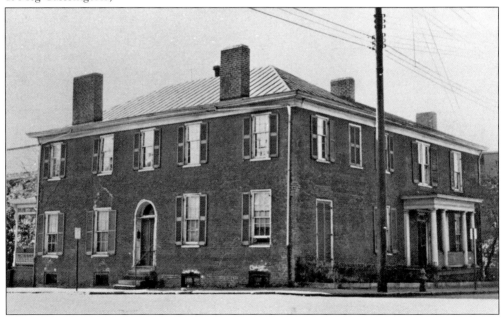

At the corner of Fifth and Madison Streets stands Joseph Nichols's Tavern, which was in operation by 1815. There were more than 12 establishments in Lynchburg licensed to sell liquor—one tavern for every 188 residents. A local legend is that Thomas Jefferson entertained Gen. Andrew Jackson at Nichols's Tavern as the victor of the Battle of New Orleans made his tour north to Washington. (Courtesy of Jones Memorial Library.)

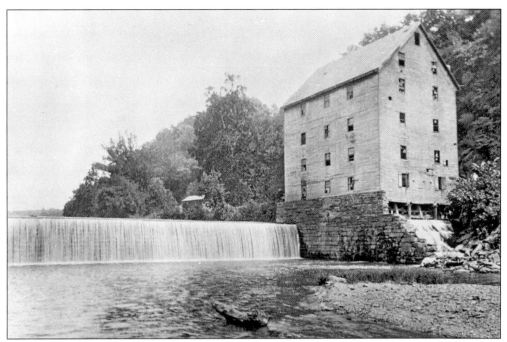

Until it burned in the 1940s, Scott's Mill was a familiar landmark on the Amherst County side of Scott's Dam. Its proximity to Lynchburg meant that its products could be transported within a few minutes to local warehouses. The Scott family operated the mill into the early 1900s; when it closed, it became an easy target for arsonists. (Courtesy of Ronnie Tucker.)

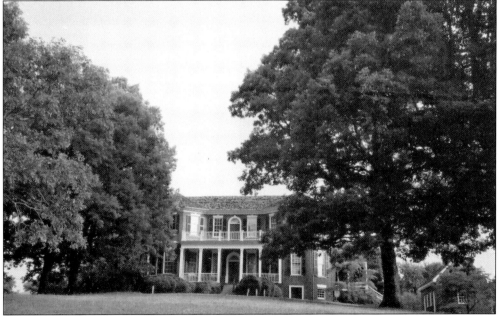

One of the grandest houses in Lynchburg is Point of Honor, built by Dr. George Cabell c. 1815. His most famous patient was Patrick Henry. A local story claims the land on which the house was built was a clandestine dueling ground—hence the name Point of Honor. The house has been carefully restored and furnished, becoming one of Lynchburg's most popular tourist destinations.

31

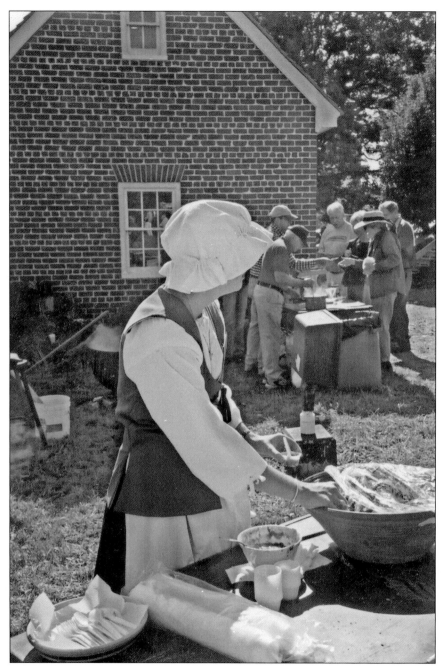

Perhaps the most important dependency at Point of Honor was the kitchen. Mansion houses were built with the kitchen as a separate structure to reduce the possibility of fire and to prevent the smells associated with food preparation from infiltrating the main house. The kitchen was located fairly close to the main house so that dishes could be delivered to the dining room quickly. Large kitchens like that at Point of Honor were equipped with at least one baking oven as well as an open hearth. Although modes of preservation were known and practiced by accomplished cooks, most of the produce and meat consumed in the 1800s was fresh. A number of cookbooks were published in the 19th century, but most cooks relied on recipes passed down from generations.

All that remains of Tate Springs is a portion of a rock wall and the road that bears its name. It became a popular gathering place in the 1820s, when its waters were reported to have medicinal properties. By 1828, a large ballroom and elegant banqueting hall catered to those affluent enough to visit the watering places in which Virginia abounded.

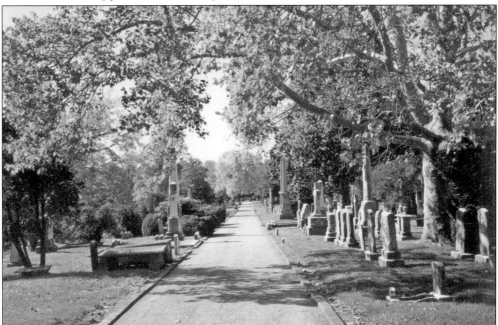

In 1824, the elders of the Presbyterian church in Lynchburg purchased a two-acre lot just outside the town limits on what would be known as Franklin Hill. While communicants in the Presbyterian church were able to select their family plots first, the new cemetery was open to all citizens in the Lynchburg area. It soon became the fashionable place to be interred.

Lynchburg was not only the shipping point for tobacco grown and cured in Central Virginia, but it also quickly became an important processing center. The first tobacco factory was on Elm Avenue near Horse Ford Road. The majority of workers were slaves rented by their masters to the factory owners. Slaves were allowed to earn money for overtime work, and some were able to buy their freedom after saving for years. Working conditions in tobacco factories, like most 19th-century American industrial sites, were appalling. Limited ventilation and dust led to serious respiratory aliments, which usually proved fatal. Safety standards were almost non-existent, and although slaves were considered valuable property, there were accidents that resulted in maiming and death. The workday often exceeded 16 hours during harvest season. (Courtesy Jones Memorial Library.)

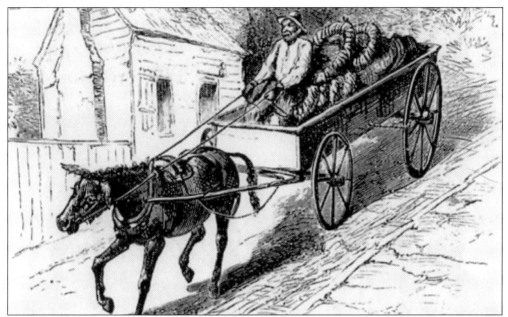

While large quantities of tobacco were shipped in hog's heads, small farmers sent their crop to market in a mule-drawn wagon. At harvest, Lynchburg welcomed farmers and their families. When the auctions were finished, they purchased essential and sometimes frivolous items to see them through the next year. Sometimes these hard-earned funds were also wasted in saloons and "fancy" houses, or brothels. (Edward King, *The Great South*, 1875.)

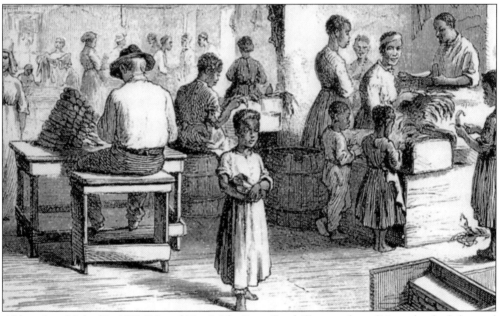

Although published in 1875, Edward King's *The Great South* illustrated conditions that had changed little despite the Civil War. *Scene in a Lynchburg Tobacco Factory* is an excellent example. The majority of the workers were black, and children formed much of the labor force. Many of the young women included here probably worked in a similar factory when they were youngsters—and still slaves. (Edward King, *The Great South*, 1875.)

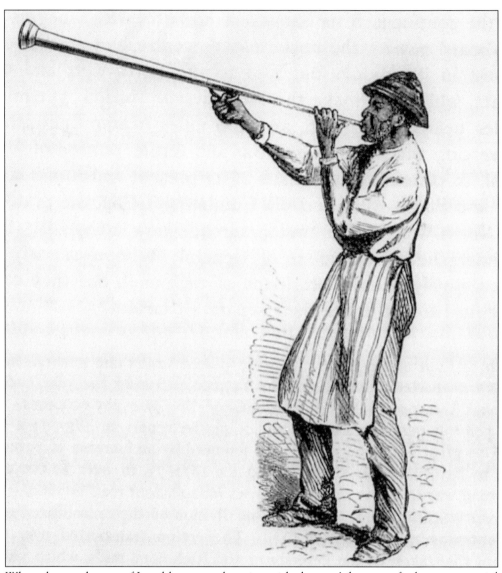

When the warehouses of Lynchburg were bursting with the year's harvest of tobacco, potential buyers were summoned to the noon auction by a slave blowing a long instrument which resembled an English coachman's horn. Once everyone had assembled, there began a ritual that would alter little as the decades and the centuries changed. The rapid patter of the auctioneer was like a song in some long-forgotten language to the uninitiated, but it was music to the ears of the tobacco farmers of Central Virginia. Before the Civil War, the economy of Lynchburg was based essentially on the cultivation, sale, and processing of tobacco. When the harvest was good, all levels of the economy benefited; likewise a bad year might have the opposite effect. Lynchburg was the second wealthiest city in the United States per capita in 1855. It was surpassed only by the whaling industry in New Bedford, Massachusetts. (Edward King, *The Great South*, 1875.)

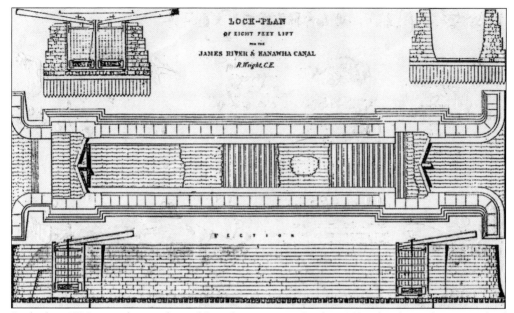

In the late 1700s, canals transformed British commerce. By the 1820s, this form of transport had inspired numerous schemes to link America's vast river network. Lynchburg was gripped by "canal fever" in the 1830s, as the James River–Kanawah Canal inched closer to the Hill City. This lock plan is one of a number of drawings by engineers that made the canal a reality. (Courtesy of the *Lynchburg News*.)

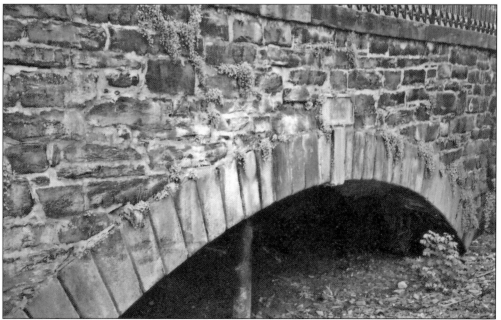

At the bottom of Ninth Street stands an 1839 bridge, one of the few remaining relics of the James River–Kanawah Canal, which finally linked Lynchburg to Richmond in 1840. The projected waterway was supposed to facilitate commerce and travel from Norfolk to the Ohio River. The canal did not advance beyond Buchanan, Virginia, because faster and less expensive railroads had replaced it by 1855.

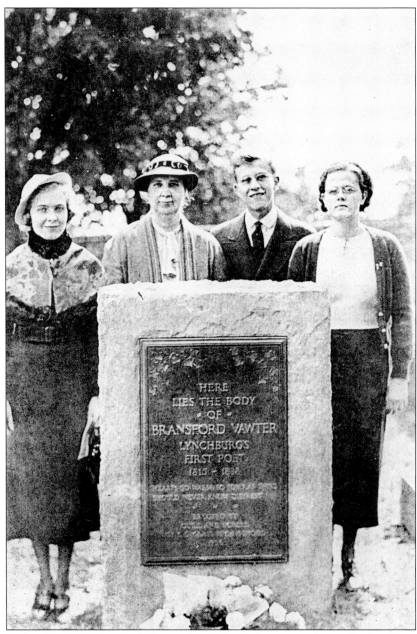

On November 15, 1833, Bransford Vawter, Lynchburg's first poet of note, died at the age of 23 from tuberculosis. The son of a tailor, he displayed an early interest in literature, especially poetry. His most famous poem, "I'd Offer Thee This Hand of Mine," was first published anonymously in the *Southern Literary Messenger* and became a national sensation. When the poet's identity was discovered, Vawter was briefly a local celebrity but was soon relegated to the realm of the "once fashionable." He died shortly thereafter and was buried in an unmarked grave in the Old City Cemetery. A century later, Evelyn Moore, who taught English at E. C. Glass High School, was responsible for rescuing Bransford Vawter from obscurity. She is shown with members of the Quill and Scroll Literary Society at the dedication of his monument. (Courtesy Jones Memorial Library.)

When "I'd Offer Thee This Hand of Mine" was published, it was set to music. Since the poem was anonymous, Vawter received no royalties. Music was not covered under copyright law until 1831. The cover of this version of the song shows the perfect couple, a Puritan maiden clinging to the arm of a young man who resembles Prince Albert, the consort of Queen Victoria. (Courtesy of the Potter Collection.)

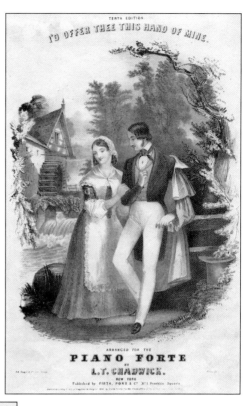

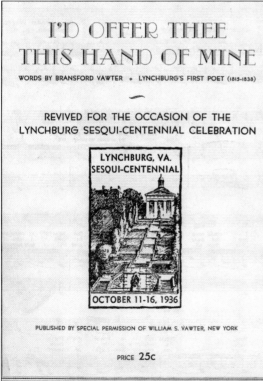

In 1936, "I'd Offer Thee This Hand of Mine" was published as part of Lynchburg's Sesqui-Centennial Celebration. Like Robert Burns, whose life was also tragic, Bransford Vawter had attempted to rise above his class. He supposedly even loved a prominent young lady. In the 1800s, such romantic aspirations rarely prospered. By 1936, his belated fame gave Lynchburg's first poet overdue respectability. (Courtesy of the Potter Collection.)

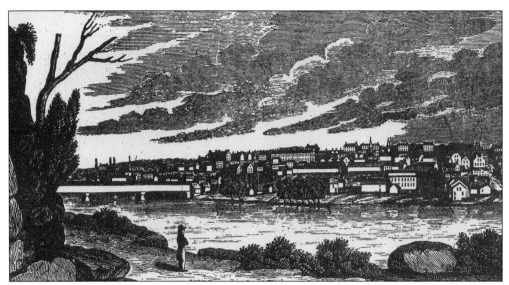

In 1845, Henry Howe's *Historical Collections of Virginia* included one of the earliest panoramic views of Lynchburg. However, the town's most familiar structure is missing from the skyline—the Federal-style courthouse would not be built for another decade. Howe's view from the Amherst County side of the James River shows a community stretched as far as the eye can see along the water's edge. (Courtesy Jones Memorial Library.)

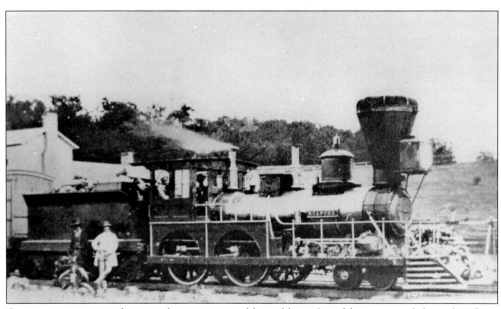

Overcoming a series of seemingly insurmountable problems, Lynchburg entered the railroad age with the arrival of the Virginia and Tennessee Railway in 1852. The *Roanoke* was one of the first engines to service that line. Before the end of the decade, the Orange and Alexandria and the Southside Railway would provide service to Lynchburg, making it one of the most important rail centers in the South. (Courtesy Jones Memorial Library.)

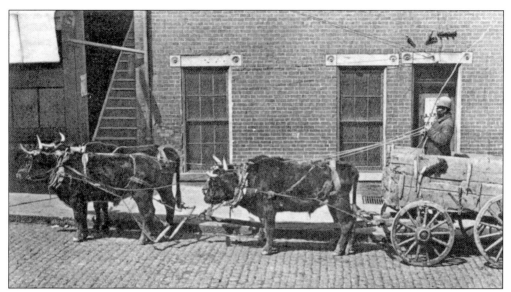

Despite the presence of the canal and the railroad in 19th-century Lynchburg, a prevalent mode of transport was horsepower, or in the case of heavy loads ox power. The sight of one or two yoke of oxen lumbering along the streets, particularly in the vicinity of the tobacco warehouses and factories, was a familiar sight. Although gentle, it took skill to manage a yoke. (Courtesy of the Potter Collection.)

A sign of Lynchburg's continuing prosperity, the commercial structure that now houses Amazement Square was built in 1853 at the corner of Ninth and Jefferson Streets on the edge of the canal. It has withstood floods, inner-city decay, and urban planning to serve many purposes, but perhaps none as important as housing the city's children's museum.

In 1855, a third cemetery was created outside the city limits on 30 acres of land. Quickly the neighbors brought suit to stop the development of Spring Hill Cemetery, but they failed. John Norman of Philadelphia designed the romantic landscape that became the next fashionable burying ground for local citizens—and so it remains over 150 years after it was opened.

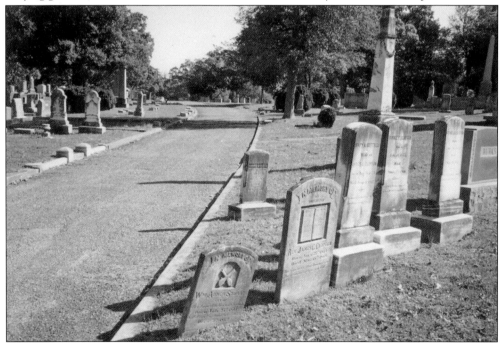

Among the early plots purchased in Spring Hill Cemetery was that of the family of the Reverend James C. Clopton. His father was the minister at the First Baptist Church, but he resigned his position in 1830 to become the pastor of the first free black congregation in Lynchburg. Clopton followed in his father's footsteps, but his son died during the Civil War.

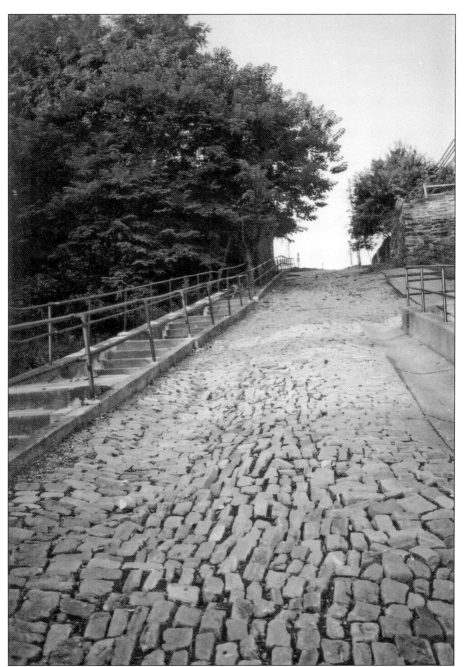

Hidden in the heart of downtown Lynchburg, between Church and Court Streets, lies Tenth Street—a relic surviving from the middle of the 1800s. The city fathers considered the hill too steep and the street too narrow to pave with expensive asphalt in the late 1940s, so it became an unrestored link to the past. Most of Lynchburg's streets were dirt tracks until the second decade of the 19th century. In wet weather, they were a sea of mud, and in periods of drought, the wind covered everything in red dust. Slowly the main streets were paved. First they were layered with sand, then covered with a base of crushed stone upon which cobbles or rough-cut stones were laid without mortar to permit easier absorption of excessive moisture.

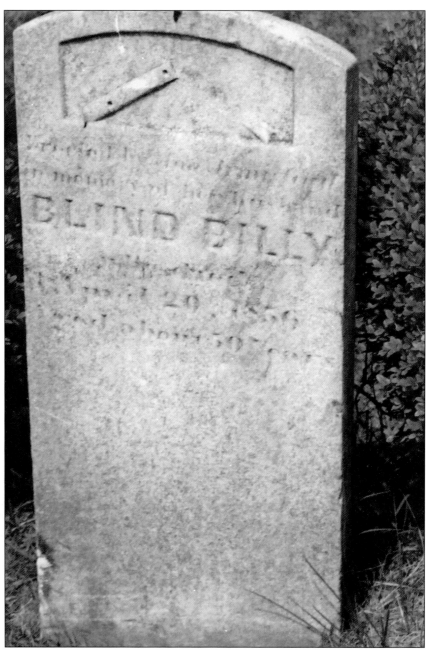

Before the Civil War, Lynchburg had the largest population of freed blacks in Virginia, but slavery still dominated the local economy. Attempts to halt the sale of slaves within the city limits were thwarted by state laws, but manumission was still possible. Sometimes slaves were freed upon the death of their owner, if specifically mentioned in a will. Some slaves were able to save enough money to buy their freedom or that of a close relative. Perhaps the most unusual example of legal deliverance from servitude was the case of "Blind Billy" Armistead. A virtuoso performer on the fife, he was so popular that the citizens of Lynchburg purchased his freedom by public subscription. When he died on April 19, 1855, he was buried in the Old City Cemetery. His tombstone bears a broken fife, symbolic of Lynchburg's loss.

Before the Civil War, education was the privilege of the few who could afford it. Students were separated by gender. A highly regarded school was the Lynchburg Female Seminary, built in 1854 at the corner of Court and Twelfth Streets. Here young ladies who were to lead the next generation's local society were carefully schooled in the useful "womanly arts." (Courtesy Jones Memorial Library.)

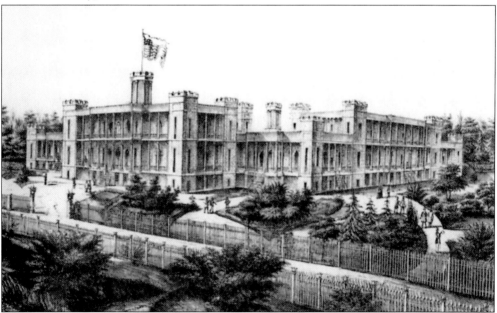

In 1856, to save their sons from potential contamination from abolitionist propaganda, a number of parents withdrew them from Madison College in Uniontown, Pennsylvania. These scholars and some professors settled in Lynchburg, and the city's first college was founded. Lynchburg College's military character was reflected in the design of its buildings. Unfortunately its history was brief. In 1861, the faculty and students marched off to war. (Courtesy Jones Memorial Library.)

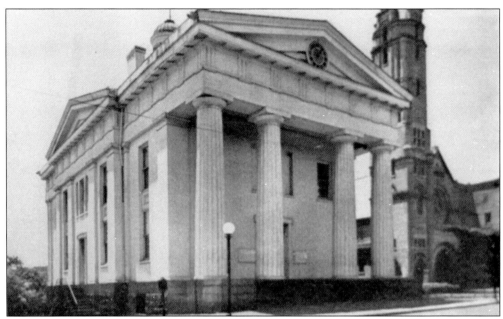

A popular complaint in the local papers in the early 1850s was about the sad state of Lynchburg's courthouse. By 1855, it had been replaced by the handsome, Greek Revival structure that is still the signature of the city and has even graced a national coin. The most obvious departure from the classical Greek design was the cupola, which acted as a lookout for local fire companies. (Courtesy Jones Memorial Library.)

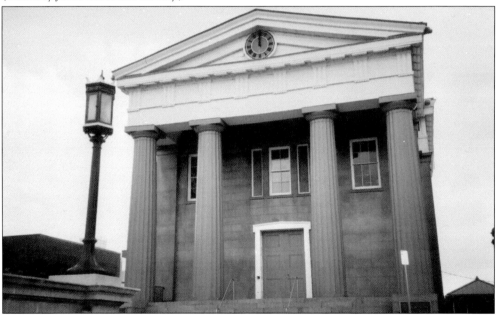

In 1976, the century-old courthouse became the heart of the Lynchburg museum system. Countless layers of white paint were removed, and its imitation sandstone finish was restored. The Doric columns were repainted the salmon pink color so popular with the ancient Greeks. Once the exterior was refurbished, extensive restorations have been continued on the interior of the Lynchburg Courthouse.

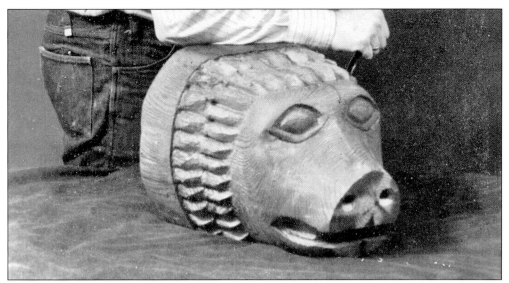

Perhaps the most charming parts of the design of the Lynchburg Courthouse are the eight wooden, lion-headed gutter spouts that more closely resemble pigs than the king of beasts. These original examples of 19th-century folk art were too fragile to be reused. Michael Creed, a local artist, produced exact replicas of the heads. Lions once again glower and spew rain on Court House Square. (Courtesy of Michael Creed.)

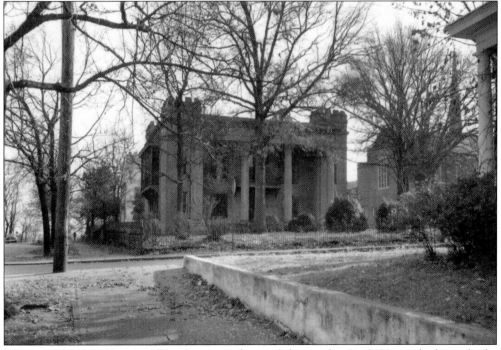

The Lynchburg College buildings became a hospital during the Civil War and a barracks for Federal soldiers during Reconstruction. The hope that a college might once again occupy the site soon faded. Some buildings were converted into private homes, like that of the Winfree family. Ironically, the last of the college buildings vanished as Lynchburg marked the bicentennial of the founding of Lynch's Ferry. (Courtesy Jones Memorial Library.)

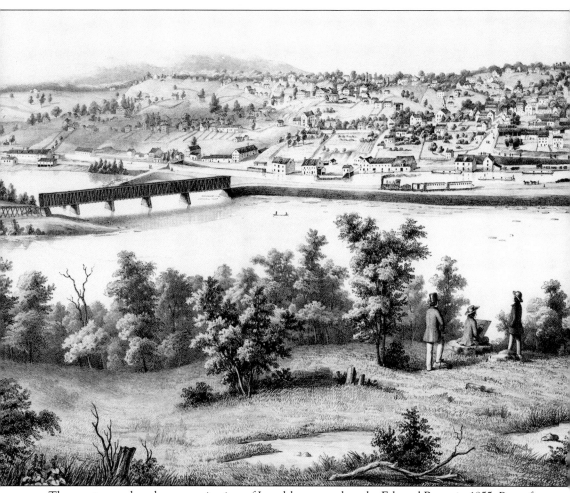

The most reproduced panoramic view of Lynchburg was done by Edward Beyer in 1855. Part of a series, this beautifully colored print captured the city at the height of its prosperity. Crowning the hill above Ninth Street stands the newly completed courthouse, a fitting symbol for a city that had grown from a few rough-hewn houses to an urban community with a population close to 7,000. The

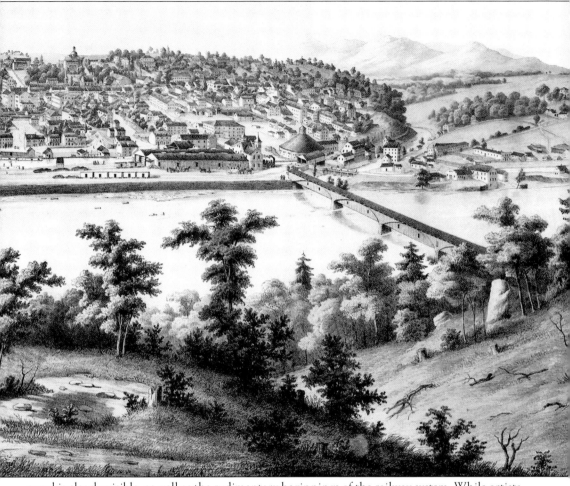

canal is clearly visible, as well as the rudimentary beginnings of the railway system. While artists may take license with their subjects, Beyer captures a fairly accurate view of the most important city west of Richmond on the eve of the Civil War. Obviously proud of his accomplishment, Beyer painted himself into his view of Lynchburg. (Courtesy of Jones Memorial Library.)

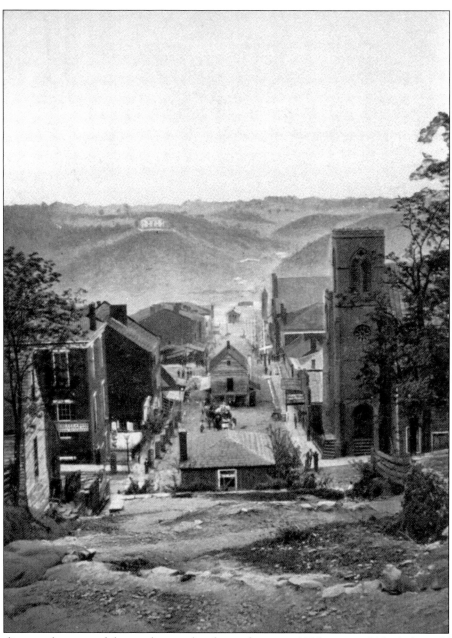

Standing on the steps of the newly completed courthouse in 1856, one could look down Ninth Street past the Market House to the old covered bridge that spanned the James River. From this vantage point, the canal and the new Virginia and Tennessee Railway were clearly visible. Lots that had been wooded or waste land were giving way to elegant new homes perched on the hills. A generation earlier, the City of Lynchburg—a proud title it had borne since 1852—was linked to the outside world only by the river and the mud tracks that passed for roads. Now it was possible to travel to neighboring cities in a matter of hours by rail, and news could pass through the wires of the telegraph in minutes. Life in Lynchburg was good and growing better day by day. The path that led from Court Street to Church Street might be rough, unsightly, and uneven, but in time that too could be transformed. (Courtesy of the Potter Collection.)

Three

CITY OF SEVEN HILLS
1857–1906

For Lynchburgers 1857 to 1906 was a tragic yet remarkable time span. The Civil War left the city relatively unscathed in a physical sense. In 1865, some citizens assigned this blessing to Providence; others, along with current scholars, credited Gen. Jubal Early and his subordinates' able defense in the Battle of Lynchburg (June 17–18, 1864). Still the Old City Cemetery's rows of graves bear witness to the thousands of men, Confederate and Union, who died of wounds or disease in the city's numerous hospitals.

Lynchburg's transportation systems had heightened its value to both Confederate and Union forces. Along with its canal that functioned until 1879, three railroads converged here. After the war, the city remained a vital link in America's expanding rail system for generations.

Transportation, diversified industry, and a growing emphasis on education helped Lynchburg recover from war and Reconstruction. By the 1870s, it encompassed all the seven hills that have provided one of the city's nicknames. Lynchburg (or Court House Hill), Federal, Diamond, Franklin, Garland, College, and Daniel's Hills became focal points of urban development, with elaborate houses, churches, and more functional public buildings like Diamond Hill's firehouse.

With the mandate of public education for children in 1870, Virginia took a long-overdue step into modernity. Lynchburg soon organized public schools segregated by gender and race. Concern for children also led to orphanages established by the Presbyterian church, the Odd Fellows fraternal order, and the reclusive millionaire Samuel Miller—whose will also endowed the city with the park that bears his name.

The demise of old Lynchburg College stimulated renewed interest in higher education. Within 18 years, four colleges opened their doors. Chartered in 1888, Virginia Seminary and College (currently Virginia University of Lynchburg) educated African American men and women. Incorporated in 1891, Randolph-Macon Woman's College commenced operations in 1893. Founded in 1901, Sweet Briar College in Amherst County welcomed its first class of young women in 1906. Transforming the defunct Westover Hotel into a pioneering coeducational institution in 1903, Virginia Christian College (renamed Lynchburg College in 1919) offered yet another learning option to a new century full of potential promise.

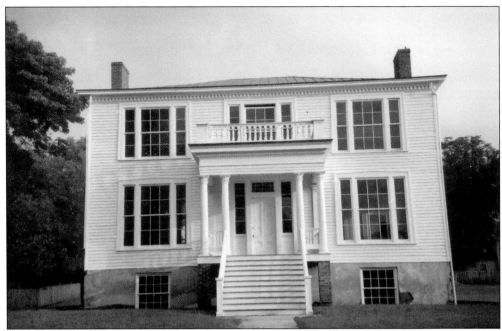

Around 1857, Judge William Daniel Jr. built a Greek Revival mansion on the crest of a hill overlooking the James River in what is now the Daniel's Hill Historic District. Its name, Rivermont, may have been the invention of Judge Daniel's second wife, Elizabeth Cabell. Recently saved from certain demolition, the house has been carefully restored to its former magnificence.

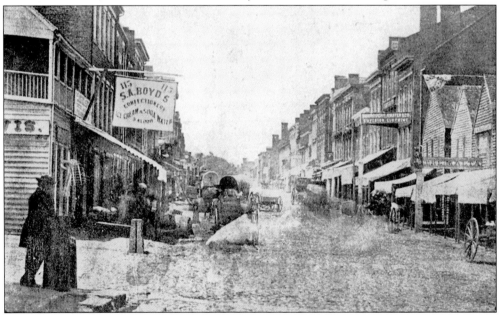

This 1859 view of Lynchburg's Main Street looking west from Ninth Street resembles the scene from a Hollywood western. A year later, on June 23, 1860, on the corner of Twelfth and Church Streets, there was a shoot-out among the editorial staffs of the rival local newspapers, the *Virginian* and the *Republican*. This unexpected violence was indicative of the depth of prewar bitterness. (Courtesy of Jones Memorial Library.)

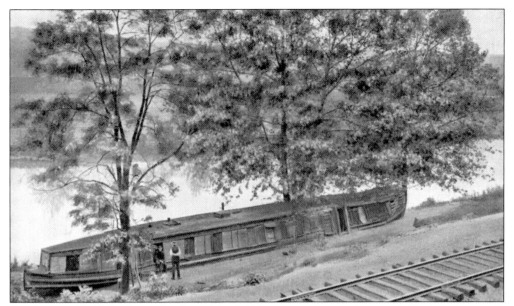

On August 12, 1861, the packet boat *Marshall* began service on the canal. During the war, it transported wounded soldiers to Lynchburg, where numerous hospitals were located. On May 13, 1863, the body of Gen. Thomas "Stonewall" Jackson, who died after the Battle of Chancellorsville, was transferred from a railway car to the *Marshall* for the journey from Lynchburg to Lexington for burial. (Courtesy of the Potter Collection.)

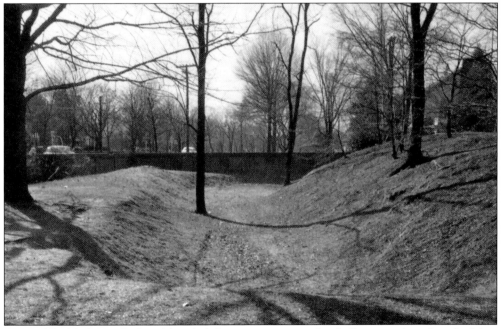

General Early's design for Lynchburg's defense was a semicircle of rifle pits and earthworks. Most of these barriers have vanished as the city has grown westward, but a century ago, a portion was preserved at Fort Early. Over the decades, weather and settling have reduced the great mounds of earth. Trees and shrubs now grow where troops stood waiting for the Union attack. (Courtesy of the Potter Collection.)

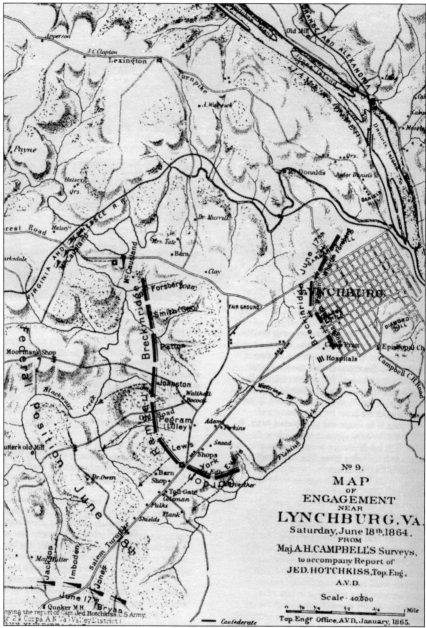

No 9.

MAP
OF
ENGAGEMENT
NEAR
LYNCHBURG, VA.
Saturday, June 18th, 1864.
FROM
Maj. A.H. CAMPBELL'S Surveys,
to accompany Report of
JED. HOTCHKISS, Top. Eng.,
A.V.D.

Scale - 40.000

Top. Engr Office, A.V.D., January, 1865.

Under orders from Gen. Ulysses S. Grant, Maj. Gen. David Hunter marched toward Lynchburg with the intent of crippling the Confederacy by destroying the canal and the rail lines that converged in Lynchburg. Had Hunter acted with swiftness and husbanded his supplies with care, he might have succeeded. His dismal failure soon ruined his military career. Confederate general Jubal Anderson Early saved Lynchburg because he did move with alacrity, making excellent use of the trains from Charlottesville. General Early supervised the rapid construction of a defense line outside the city and persuaded Hunter that Lynchburg was filled with troops by using a clever stratagem. On the night before the battle, an empty train ran back and forth over a bridge reinforced with tin. The noise convinced Hunter that he had reached Lynchburg too late. (Courtesy of the Lynchburg Foundry.)

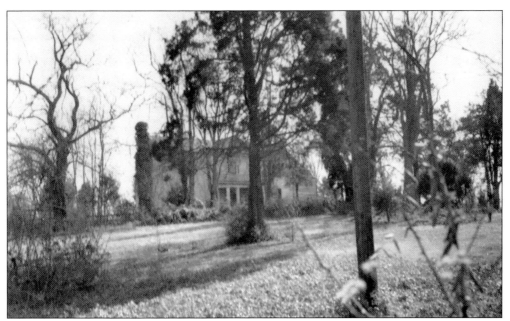

During the Battle of Lynchburg, the Locust Thicket House on Old Forest Road was caught in the crossfire between Lynchburg's defenders and General Hunter's troops. It was the home of a Revolutionary War veteran, Maj. Samuel B. Scott. Since 1864, the house has been a private residence, an antique shop, and a restaurant but still bears the scars of battle. (Courtesy of the Potter Collection.)

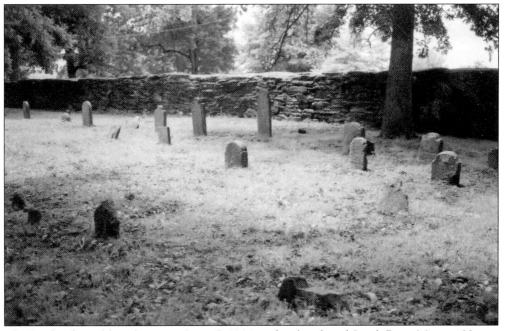

The Battle of Lynchburg began on June 17, 1864, at the abandoned South River Meeting House. Union soldiers moved through the Quaker cemetery toward the ruins of the meetinghouse defended by Confederate troops who were forced to withdraw. That night, the victors camped by the road and buried their comrades on both sides of the wall of the old Quaker cemetery.

Lynchburg was a city of hospitals during the Civil War. Every available space was devoted to treating the sick and wounded from both sides. Virginia farmers were required by law to abandon the cultivation of tobacco in favor of foodstuffs. Thus the empty tobacco warehouses and factories were particularly valued as hospitals. Unfortunately only two of these buildings still survive.

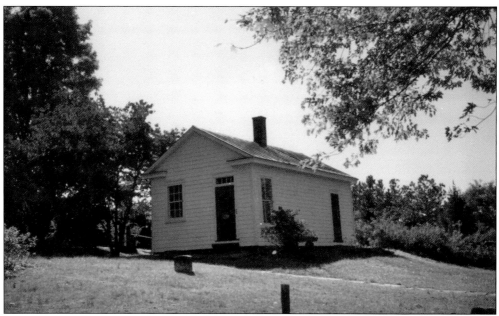

The Pest House Museum located in the Old City Cemetery commemorates the work of Dr. John Jay Terrell, who worked among the soldiers stricken with smallpox and measles. By using innovative techniques, Dr. Terrell, who had been reared a Quaker, was able to reduce the death rate from 50 percent to 5 percent. The museum contains a replica of his office and his smallpox ward.

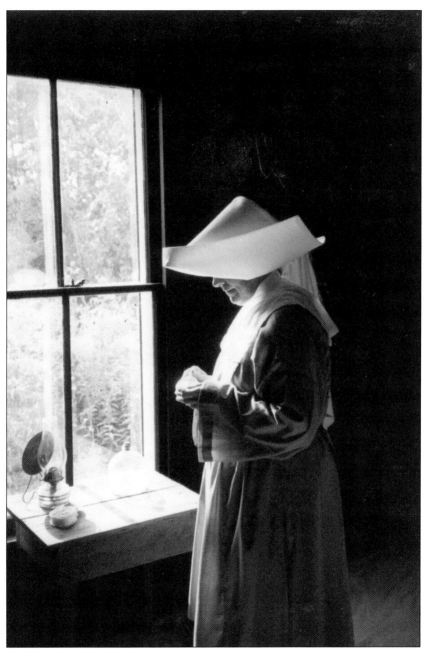

The only nurses who were willing to work with the victims of smallpox in the Pest House were the Sisters of Charity. The only clergyman who was not afraid to minister to these gravely ill soldiers was the chaplain of the Sisters of Charity, Fr. Louis-Hippolyte Gache of the Society of Jesus. The Sisters of Charity were noted for their work with the sick and wounded on both sides of the line. In the mid-1800s, despite Florence Nightingale's work in the Crimea, nursing was not considered a respectable profession for women. During the Civil War, unmarried women were not allowed to serve as nurses. Only married or widowed women or nuns could perform nursing duties; thus the Sisters of Charity, with their dedication and training, were a welcomed addition to the Civil War hospitals of Lynchburg.

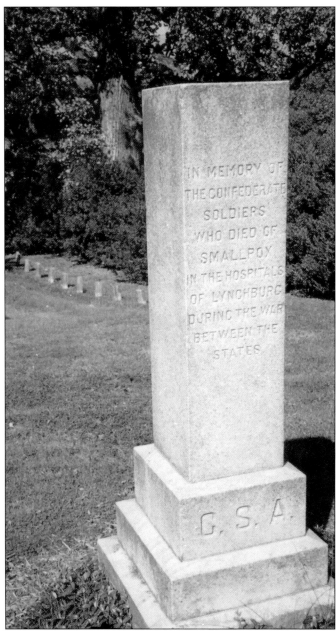

Despite the efforts of Dr. Terrell and the Sisters of Charity, some soldiers still died of smallpox. In the Confederate section of the Old City Cemetery, there is a simple monument dedicated to the 99 men who died of this disease from 1861 to 1865. It is surprising that so many contracted smallpox when the British physician, Edward Jenner, had developed an effective preventive treatment for the disease at the end of the previous century. Both the Federal and Confederate governments attempted to inoculate as many of their military personnel as possible, but it was a mammoth task. Many believed that inoculation might cause the disease, and there was also a belief that serious scarring could occur if the site of the vaccination became infected. Many of the men who succumbed to the disease were from rural areas where modern medical treatments were relatively unknown or held in great suspicion.

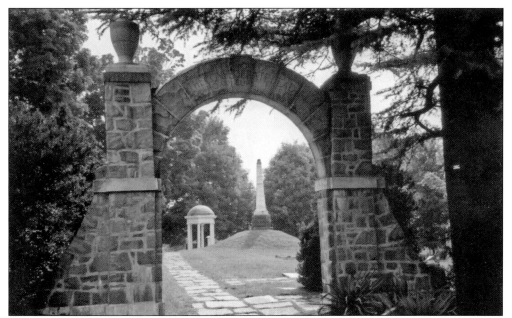

The Confederate section of the Old City Cemetery contains the graves of over 2,000 Confederate soldiers and one Union soldier—left by mistake because he was from North Carolina—and the oldest monument in Lynchburg commemorating a specific event. It was erected in 1868 through the efforts of the Ladies Memorial Association. The ceremonial arch and belvedere were erected in the 1900s.

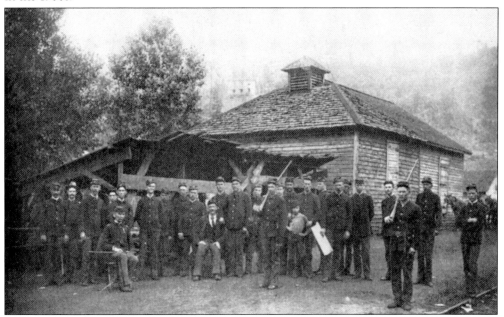

After the surrender of General Lee to General Grant at Appomattox in April 1865, Lynchburg was occupied by Union troops until the end of Reconstruction in Virginia in 1870. Federal troops were stationed at various points in the city, including former Confederate Camp Davis. In the next century, the home of poet Anne Spencer would be constructed in this same area. (Courtesy of Jones Memorial Library.)

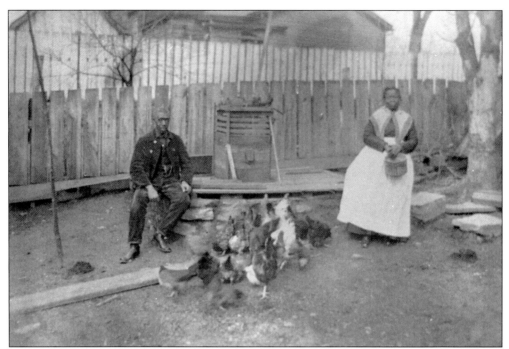

Once free, the black citizens of Lynchburg could live as they chose, knowing that their labor and its profits were their own. This elderly couple proudly displays their flock of chickens in their own backyard. Lynchburg had the largest free African American community in Virginia before the war; they now assumed the leadership of the entire black population. (Courtesy of Jones Memorial Library.)

One of the most important aspects of Reconstruction was the establishment of a Freedmens' School under the direction of Jacob Yoder. Before the war, it was illegal to teach blacks to read and write. Now, despite repeated intimidation, Yoder's school was almost overwhelmed with men, women, and children anxious to learn. Education was and is the key to a better life. (Courtesy of Jones Memorial Library.)

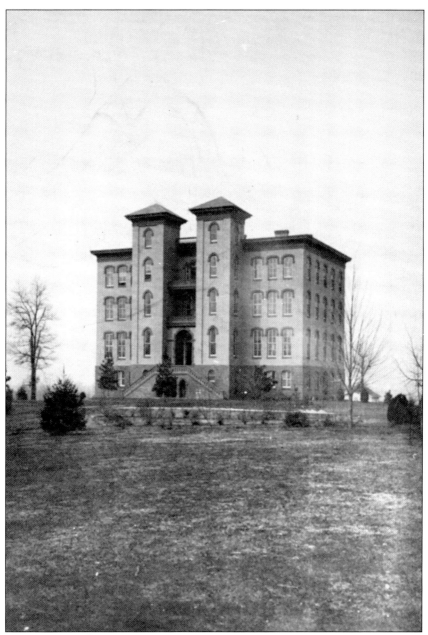

In the will of the eccentric philanthropist Samuel Miller, who died in 1869, there were a number of legacies for the citizens of Lynchburg. Among them was the construction of an orphanage for girls. Miller was a self-made man who amassed a large fortune from dabbling in the stock market. He never married and spent his final years a virtual recluse. Completed in 1872, the Miller Home became the refuge of hundreds of young women who might have been trapped in menial or even degrading occupations for the rest of their lives. Supervised by a dedicated staff, the girls received an education equal to that found in the city's schools as well as practical skills that fit them for productive lives in adulthood. The Miller Home remained at its original site until 1959, when it moved into a modern facility, and the property was sold to the developers of Pittman Plaza Shopping Center. (Courtesy of Jones Memorial Library.)

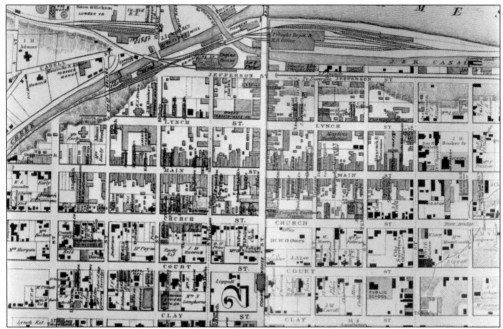

This is a portion of an extensive map published in 1877 by O. W. Gray of Philadelphia. It details the development that occurred in the heart of the city of Lynchburg in the 1800s. It is particularly interesting when compared with Stith's map done barely 80 years earlier. (Courtesy of Jones Memorial Library.)

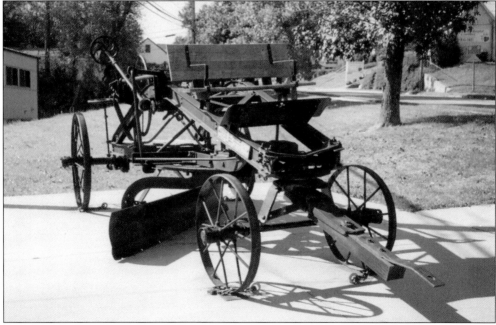

Perhaps one of the most interesting pieces of sculpture on display in Lynchburg is the horse-drawn road grader, "American Big Winner No. 31," manufactured in 1880. It stands at the end of the bridge on Martin Luther King Boulevard and is on permanent loan to the City of Lynchburg by Thomas Gough.

One of the oldest churches that remains the home of its original congregation is Court Street Baptist Church. Completed in 1879 and dedicated in 1880, it has counted among its membership many of Lynchburg's African American leaders. Because of the number of free blacks living in Lynchburg before the Civil War, exclusively black churches had been founded before 1860. After the war, former slaves were free to organize and build their own churches. The first home of what became the church was an abandoned theater. It burned in 1866, but a year later a new building had been constructed. Two years later, during a crowded wedding celebration, a piece of decorative plaster fell, causing the congregation to panic. Many believed that the entire structure was collapsing. In the melee that followed, eight people were trampled to death and many more injured. That church was abandoned, and the present building was then constructed.

In 1881, a young inventor, James A. Bonsack, patented a cigarette rolling machine that was manufactured in Lynchburg. It made him a wealthy man and changed the economic destiny of the city. As Americans began to favor cigarettes over chewing tobacco, the center of the processing industry shifted farther south. Lynchburg was forced to diversify its economy in order to survive. (Courtesy of Lynchburg Foundry.)

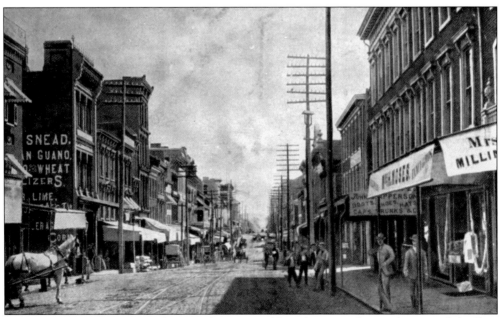

Perhaps the most prominent photographer in Lynchburg between the Civil War and the First World War was Adam Plecker. His view of Main Street looking south was made during the late 1880s and offers an interesting contrast to the similar view made in 1859. Streetcar tracks, cobbles, telephone poles, and multistoried buildings in the latest style have erased the frontier aspect of downtown. (Courtesy of Jones Memorial Library.)

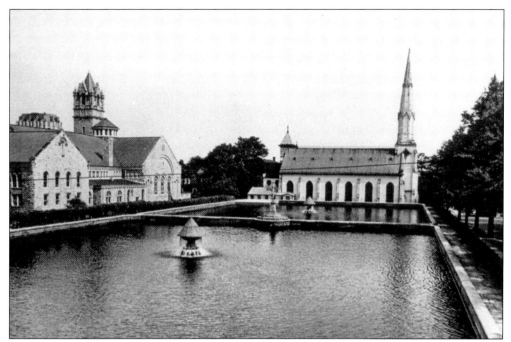

Holy Cross Catholic Church, built in 1879, is reflected in the waters of the Clay Street Reservoir, completed between 1883 and 1885. These two holding basins replaced an earlier reservoir on the same site. Between 1899 and 1902, Court Street Methodist Church, which is to the left of the reservoir, was constructed. (Courtesy of Jones Memorial Library.)

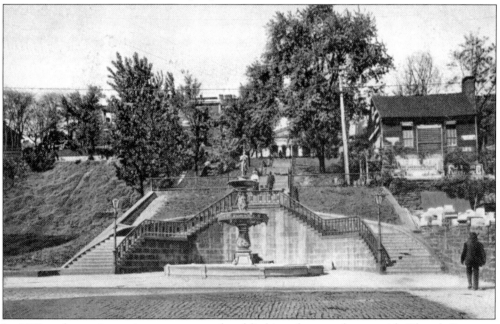

In 1883, a decorative staircase was completed linking the courthouse with Church Street at Ninth Street. At its base was a fountain that by the end of the year included a cast iron fireman holding a hose with its nozzle pointing heavenward. It was a memorial to five firemen who died in the line of duty on May 30, 1883. (Courtesy of the Potter Collection.)

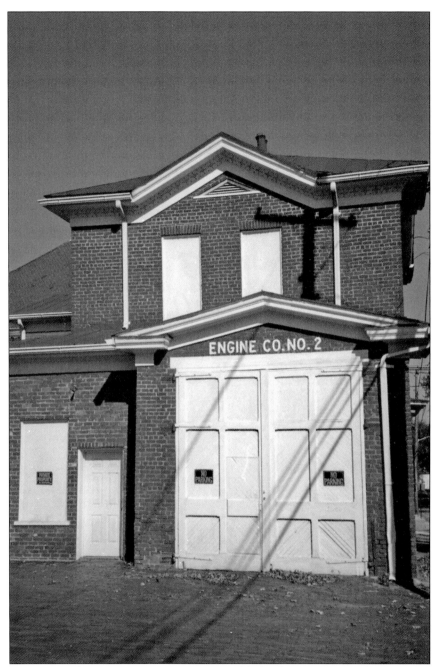

In 1883, August Forsberg, city engineer, was responsible for the Grace Street (Diamond Hill) Fire Station. It was the city's fourth fire station, but it is the oldest surviving firehouse. The city had started a fire service in 1883 staffed by professionals. Until that year, Lynchburg had been protected by a number of volunteer companies, some of which were ill trained and ill equipped. No sooner had the service been formed and funded than the tragic conflagration of May 30 took the lives of five firemen. The Grace Street Station was in use until the 1960s, when it was replaced by a larger and more modern facility. The old station was sold to the Diamond Hill Baptist Church, whose property adjoins it.

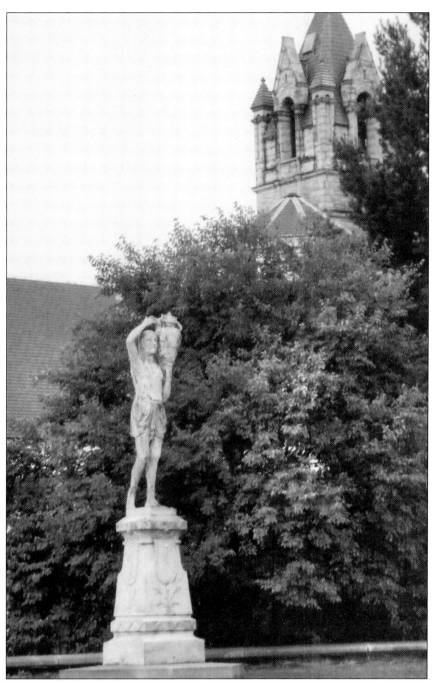

Around 1886, a statue made of zinc was placed on the barrier that divides the two basins of the Clay Street Reservoir. The young man bearing a water jug on his shoulder has been described by some as a Greek slave, but he was popularly known to the citizens of Lynchburg as "Joseph," a reference to the Old Testament patriarch who was enslaved in Egypt. The fact that this piece is cast in zinc and not the more expensive bronze probably indicates that it was mass-produced from a design by a journeyman artist. An examination of archives at city hall shows no record of the statue's origin, the name of the artist, or a purchase order for its acquisition.

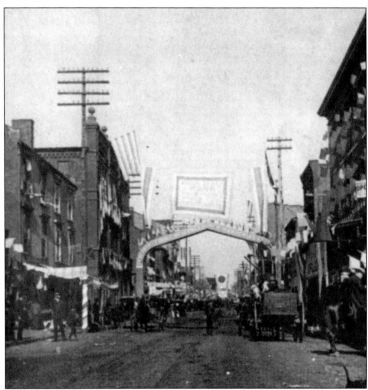

The citizens of Lynchburg did little to observe the centennial of American independence in 1876; a decade later, they held a gala celebration to mark their own one 100th birthday. This banner stretched across Main Street proclaimed that "Lynchburg Welcomes her Wandering Children Home." A centennial oak was planted in Miller Park; it is perhaps the only thing that remains from that first anniversary. (Courtesy of Jones Memorial Library.)

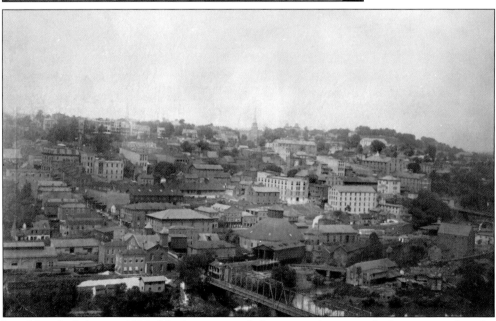

Lynchburg's skyline in 1886 ably demonstrated the tremendous growth that occurred in the city since the end of the Civil War. While the number of tobacco warehouses and factories still dominated the skyline, the character of the city's economy was beginning to change. The old covered bridge, which had been destroyed in the flood of 1870, was replaced by a sturdier iron span. (Courtesy of Ronnie Tucker.)

First Baptist Church, at the corner of Eleventh and Court Streets, is the "mother church" of all the congregations of that denomination. The present building was constructed on solid rock between 1884 and 1886. This impressive example of High Victorian Gothic was severely damaged in a devastating wind storm in June 1993, but it has been fully restored. (Courtesy of Jones Memorial Library.)

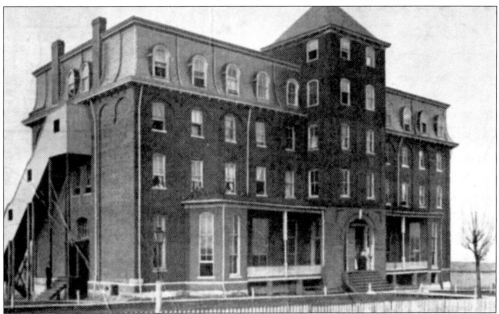

The first brick building constructed at Virginia Seminary and College was completed in 1888. It was later named in memory of college president Gregory Willis Hayes. Unfortunately, Hayes Hall was demolished a century later. Like its sister institution Lynchburg College, which lost Westover Hall in 1970, Virginia Seminary and College was deprived of a vital link with its past. (Courtesy of Jones Memorial Library.)

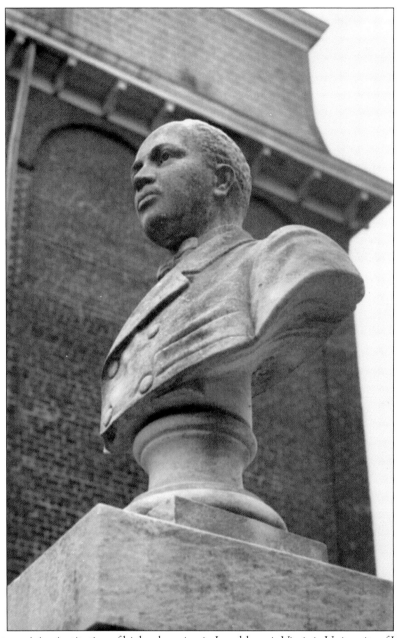

The oldest surviving institution of higher learning in Lynchburg is Virginia University of Lynchburg, formerly Virginia Seminary and College. It was chartered in 1887 by the Virginia State Baptist Convention. Unlike many black colleges founded in the decades after the Civil War that emphasized technical subjects, Virginia Seminary and College stressed liberal arts. The founders sought to provide African American students with the same academic opportunities offered to their white counterparts. Of particular importance in shaping the nature of the college was its second president, Gregory Willis Hayes, a mathematics graduate from Oberlin College. He served two terms as president before his untimely death in 1906. At the base of his marble bust are the words "Educator, Orator, Race Leader." One of the most famous graduates of Virginia Seminary and College was Anne Spencer, a leading writer of the Harlem Renaissance.

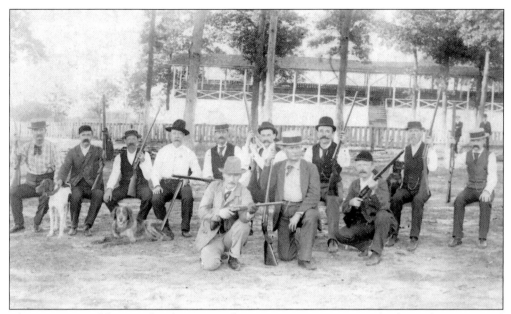

The proper use of firearms has been a manly pursuit in Virginia since the first colonists arrived in 1607. In the years after the Civil War, marksmen who defended Lynchburg in 1864 passed on their skills to the next generation of hunters. Groups like the Lynchburg Gun Club flourished in the years at the end of the 19th and the beginning of the 20th centuries. (Courtesy of Jones Memorial Library.)

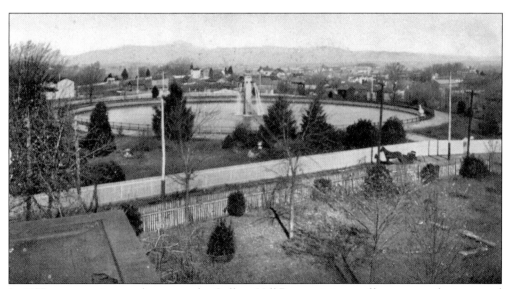

In 1877, construction was begun on the College Hill Reservoir in an effort to meet the increased demand for a safe and clean water supply. It was designed by City Engineer August Forsberg. By 1890, the site had been landscaped and provided with an oval promenade as well as a handsome cast iron pitcher of heroic proportions. (Courtesy of the Potter Collection.)

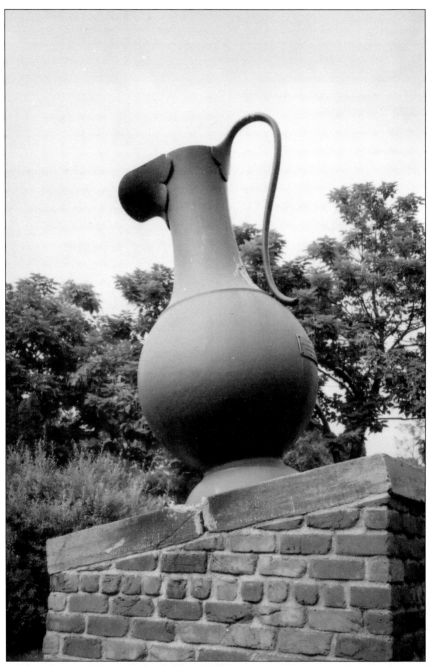

As part of the scheme to beautify the College Hill Reservoir, Glamorgan Foundry designed a cast iron pitcher that was placed just inside the decorative iron fence that surrounded the reservoir. It was presented to the city by Henry E. McWane, president of the foundry, in a formal ceremony. Glamorgan Foundry fabricated most of the iron pipes that carried Lynchburg's water to all parts of the city. The original municipal water pipes were wooden, and some of them were still in use in the 1960s. The giant pitcher poured forth an endless stream of water from the day of its dedication until the city decided to cover the reservoir. The pitcher was removed and eventually was installed in a place of honor in the Old City Cemetery with other relics of Lynchburg's past.

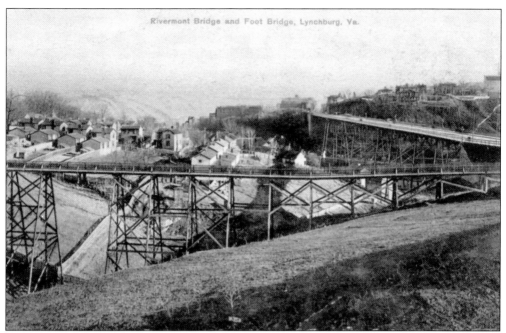

By 1891, Blackwater Gorge, which separated downtown Lynchburg from Rivermont—the first planned suburban community in the United States—was spanned by a modern iron bridge 1,200 feet in length and 136 feet in height. That was only three feet shorter than the Brooklyn Bridge. It cost $111,000 ($2 million in 2006). It could carry trolley, horse, and pedestrian traffic. (Courtesy of the Potter Collection.)

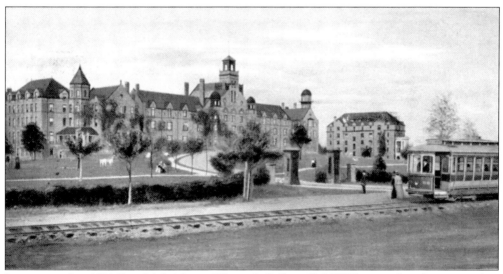

Incorporated in 1891, Randolph-Macon Woman's College (R-MWC) opened its doors to its first students in 1893. Its construction was the central focus of the Rivermont Land Company. The city fathers were persuaded to extend the streetcar tracks to the gates of the "Woman's College." R-MWC from its inception provided young women with the same quality of educational experiences found in contemporary men's colleges. (Courtesy of the Potter Collection.)

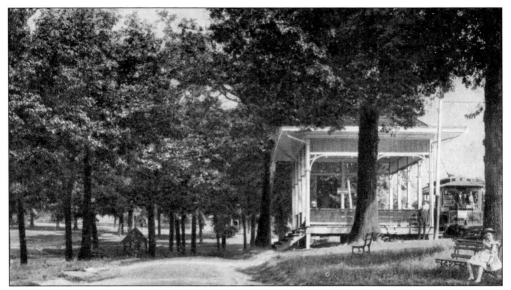

Samuel Miller left many legacies, but perhaps none was enjoyed by so many as Miller Park, which enclosed part of the old municipal fairgrounds. It was possible by the 1890s to hop on a city trolley and ride to the park to spend a quiet afternoon far from the bustle of downtown. A covered stop provided patrons a place to wait for the ride home. (Courtesy of the Potter Collection.)

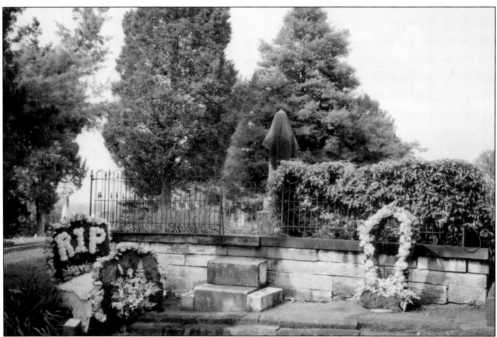

One of the most interesting features of the Old City Cemetery is the presence of a number of women who were prostitutes. Perhaps the most elaborate family plot of these women is that of Lizzie Langley, who died in 1891 after a successful career. The replica floral tributes that adorn her grave are typical of those favored at the end of the 1800s.

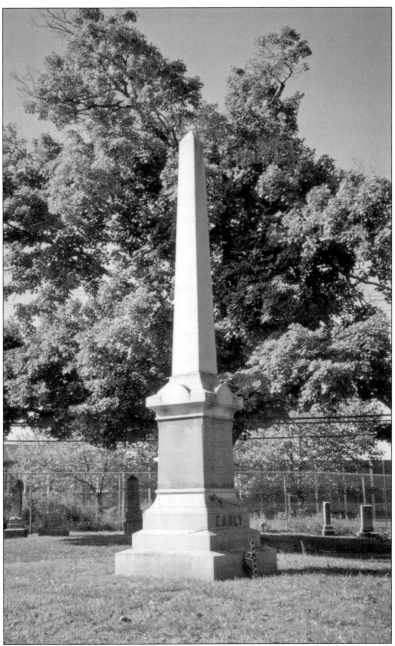

On one of the hills of Spring Hill Cemetery stands the impressive monument of Gen. Jubal A. Early, the savior of Lynchburg. He died in 1894 and was buried near the place where he directed the successful defense of the city in 1864. His funeral was conducted with full military honors and attended by the famous and the humble. Soldiers who served under him were not ashamed to weep as his flag-draped coffin passed by them. In later years, he would be joined in death by a number of his fellow soldiers and their families. Many local legends and stories have been passed for generations about this colorful unreconstructed rebel whom Gen. Robert E. Lee called "my bad old man." Although a native of Franklin County, Early chose to spend the last years of his life in Lynchburg, where he was regarded with reverence and awe.

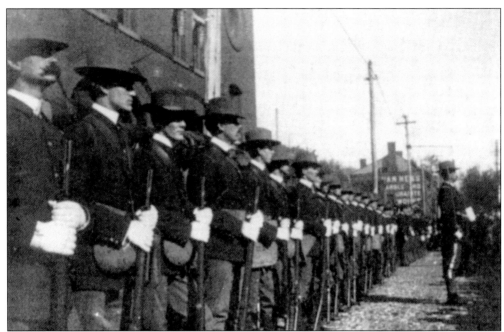

In 1898, America declared war on Spain; thus began what some have called the "great healing war" because men from every state and territory fought side by side against a common enemy for the first time since the Mexican War. As far as the eye can see stand Lynchburg's soldiers at ease along Court Street before their projected departure for Cuba. (Courtesy of Jones Memorial Library.)

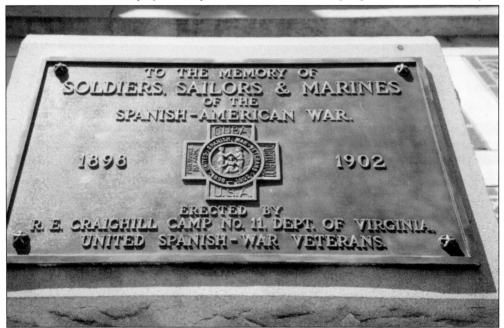

On the first level of Monument Terrace above Church Street stands a simple, rough block of granite bearing a bronze tablet in memory of the men from Lynchburg who served in the Spanish American War. It was erected by the R. E. Craighill Camp No. 11 Department of Virginia, United Spanish American War Veterans.

In 1900, the local chapters of the United Daughters of the Confederacy unveiled an impressive bronze statue mounted on a granite base. Located across the street from the courthouse, it represents a Confederate soldier facing southward, the direction from which the Union forces advanced on Lynchburg in 1864. Col. M. M. Muldoon designed it.

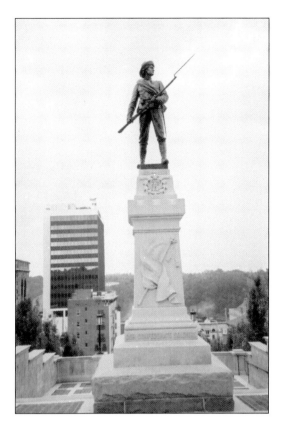

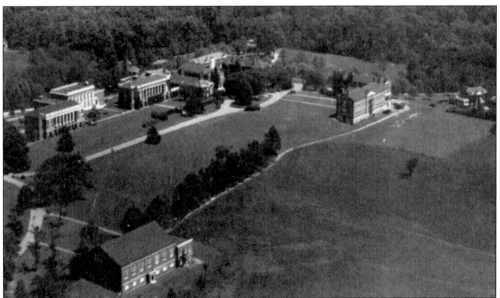

To the north of Lynchburg, nestled in the rolling hills of Amherst County, is Sweet Briar College. Founded in 1901 thanks to the generous bequest of Indiana Fletcher Williams, it welcomed its first students in the fall of 1906. By this time, Central Virginia had become a focal point for higher education. (Courtesy of Jones Memorial Library.)

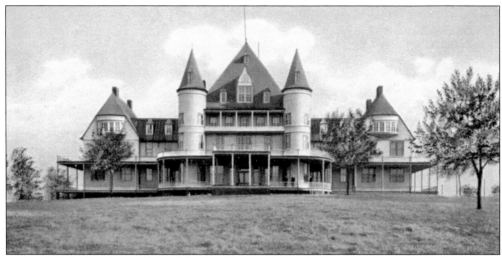

In April 1903, Josephus and Sarah LaRue Hopwood founded Virginia Christian College in the defunct Westover Hotel on the edge of the city. The second oldest four-year coeducational college in Virginia, it would change its name to Lynchburg College in 1919. A Union veteran, Hopwood decided to dedicate his life to bringing opportunities in higher education to the South while a prisoner of war in Richmond. (Courtesy of Lynchburg College.)

The Westover Hotel had been constructed in 1890 close to a series of natural springs to take advantage of the popularity of mineral spas. Its tenure as a resort was brief because of a national economic depression, but it provided the ideal venue for Virginia Christian College. The springs still spill their iron-rich waters into College Lake, but the fondness for such foul-tasting potions has vanished. (Courtesy of Lynchburg College.)

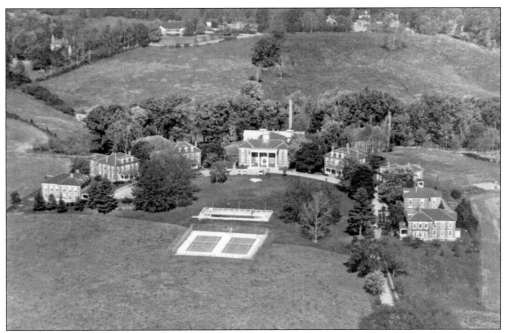

The Presbyterian Church established an orphanage on a large tract of land just beyond the property belonging to the Rivermont Company. Like Virginia Christian College, it was a coeducational institution. It maintained its own school for a number of years and provided for all the needs of the children under its care until they reached adulthood. (Courtesy of Jones Memorial Library.)

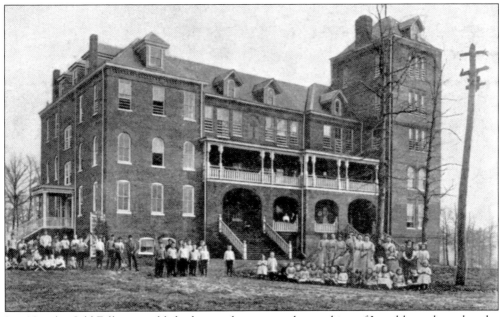

In 1904, the Odd Fellows established an orphanage on the outskirts of Lynchburg three decades after the completion of the Miller Female Orphan Asylum. This new facility, like the recently established Presbyterian Home, was for boys as well as girls. The original structure would be demolished in the early 1970s, when the home moved to the Rivermont area. (Courtesy of the Potter Collection.)

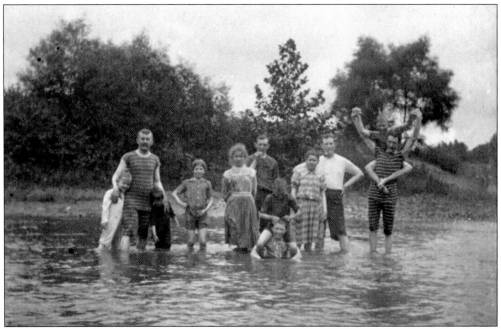

Lynchburg is blessed with a moderate climate, but the summers are often hot and humid. The James River and its tributaries have always provided recreation opportunities—although not always safe. Here a dozen citizens of all ages try to beat the heat in the shallows of the river at the beginning of the 20th century. (Courtesy of Jones Memorial Library.)

One of the most interesting events enjoyed by the citizens of Lynchburg at the beginning of the 1900s was the Flower Parade, the precursor to all the elaborate parades with their floats and bands that would mark holidays and sporting events. Ordinary carriages and wagons were covered with fresh flowers gathered from local gardens and driven through downtown to celebrate the arrival of summer. (Courtesy of the Potter Collection.)

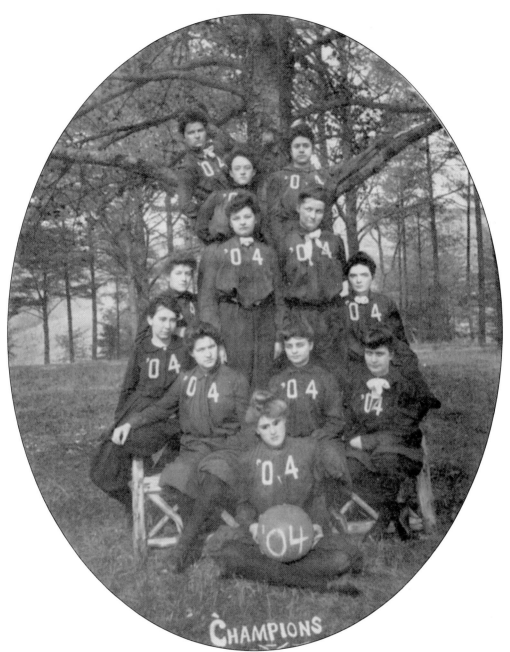

Randolph-Macon Woman's College was not only known for its academic program, equal to that of any all-male institution in Virginia, but it also was in the forefront of developing a sports program for women. In the 1800s, females were discouraged from participating in strenuous activities. At R-MWC, such views were dismissed as nonsense, and students were encouraged to be as fit as their male counterparts. For a college its size, R-MWC had a full program of team and individual sports available to suit the tastes of all its students. Many women's colleges did not provide such opportunities, thus intercollegiate competition was limited. Spirited rivalries developed between classes, and at R-MWC, the development of the Odd years versus the Even years sparked school spirit in a unique way. (Courtesy of Randolph-Macon Woman's College.)

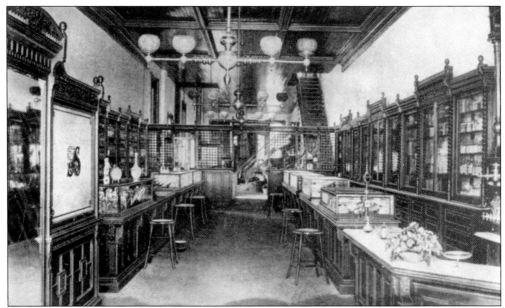

In 1906, Lynchburg was not only a manufacturing center, but it was also a popular retail center. Firms like Cohn's not only catered to shoppers from the city, but also the surrounding counties. Its elaborate cases were filled with items from the ordinary to the exotic. One could purchase goods from around the corner or around the world in the city's shops and stores. (Courtesy of Jones Memorial Library.)

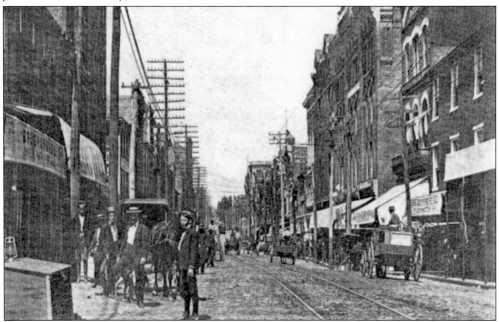

This view of Main Street looking north illustrates the rapid growth of the city since 1865. The few telephone poles in Adam Plecker's view from the 1880s have been replaced by a forest of poles and wires. The buildings are taller and the street is filled with people and vehicles. The youngster in the foreground will live to see Main Street free of horses and cobbles. (Courtesy of Jones Memorial Library.)

Four

THE CITY OF CHURCHES
1907–1956

Faith has been an integral part of Lynchburg for more than two centuries, and during the first half of the 20th century, this became more dramatically visible. Places of worship had been part of the local landscape since the humble beginnings of the South River Meeting. In the late 19th and early 20th centuries, American Romanesque, Victorian Gothic, and Christopher Wren style churches transformed the skyline of Lynchburg's central core and spread, along with the new bridges and trolley lines, into West End and Rivermont suburbs.

Faith was more than worship structures; the city's colleges were manifestations of spiritual values. Virginia Seminary and College was an outgrowth of the African American Baptist heritage. Randolph-Macon Woman's College was linked to the Methodist Church, and Virginia Christian College (after 1919 Lynchburg College) to the Disciples of Christ. Sweet Briar College's religious traditions were centered in the Episcopal Church. Private schools associated with the Roman Catholic, Episcopal, and Presbyterian faiths became part of the city's educational choices. At mid-century, Lynchburg's fastest-growing church, Thomas Road Baptist, was founded by the dynamic pastor Jerry Falwell.

The decades between 1907 and 1956 began with great promise. The nation commemorated its first permanent English settlement—although the 1907 exhibition was built in Norfolk, not on Jamestown Island. With the 1942 movie *The Vanishing Virginian,* Lynchburgers could briefly forget World War II and enjoy a noted local citizen, Capt. Bob Yancey, immortalized on the silver screen. Along with movie theaters, the Academy of Music, YMCA Island, and Riverside and Miller Park pools offered seasonal pleasures.

However, for some citizens, these entertainments were limited or altogether denied. Lynchburg, like the rest of the South, was still gripped by segregation. Soldiers who defended their country in two world wars left in segregated units. Still old attitudes of mind gradually weakened. The effects of war and internationalism, the growing influence of the colleges, population growth, and the influx of new businesses were among a number of potential agents for change beginning in the 1950s.

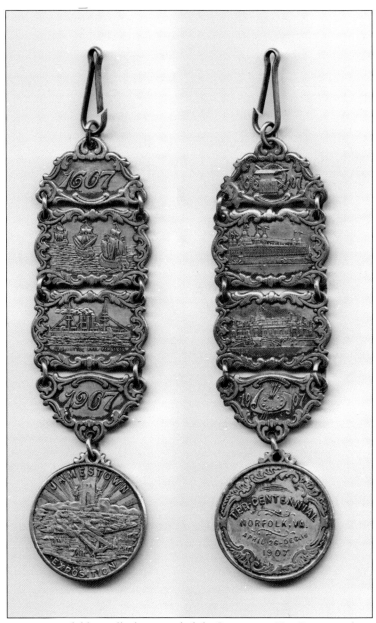

One of the souvenirs available to all who attended the Jamestown Ter-Centennial was a four-inch-long badge of nickel-silver. The obverse was composed of four ornate panels connected by jump rings. The top panel bore the date 1607; the next panel showed the three ships—the *Godspeed*, the *Susan Constant*, and the *Discovery*—that carried the first colonists to Jamestown; the third panel displayed the U.S. battleship *Virginia*; and the final panel bore the date 1907. A medallion is suspended from the final panel. It bears the words "Jamestown Exposition" and a representation of the exposition surmounted by the ruins of the church on Jamestown Island. The top panel of the reverse of the badge shows symbols of industry dividing the date 1607; it is followed by two panels illustrating some of the pavilions, while the final panel shows symbols of arts and letters dividing the date 1907. The reverse of the medallion bears the words "Ter-Centennial, Norfolk, Virginia, April 26–Dec. 1, 1907." (Courtesy of the Potter Collection.)

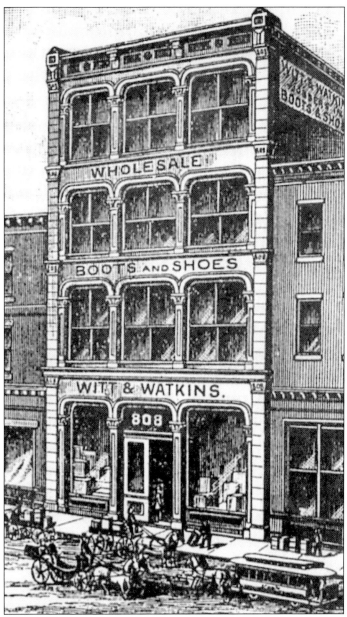

In 1907, Norfolk, Virginia, hosted the celebration of the 300th anniversary of the establishment of Jamestown, the first permanent English settlement in the New World. As with earlier international expositions, there were elaborate pavilions filled with examples of the latest products and the most modern means of production. As the exposition came to a close at the end of the year, gold, silver, and bronze medals were awarded. Lynchburg was well represented in the pavilions, but only one firm, the George D. Witt Shoe Company, won a gold medal. This engraving of the firm was made in 1887 when it was Witt and Watkins' Boot and Shoe Warehouse on Main Street between Eighth and Ninth Streets. The recipients of the various medals were required to purchase them, and it is not known whether Witt bought a medal. Before the decade ended, Craddock and Terry Shoe Corporation—his only real competition at the exposition—absorbed his firm. (Courtesy of Jones Memorial Library.)

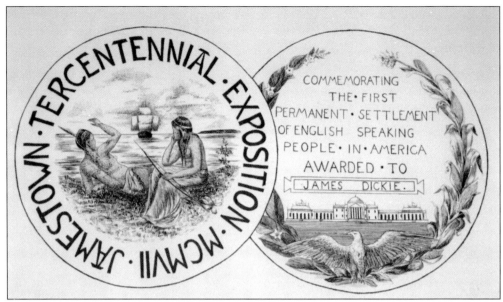

The medals of gold, silver, and bronze were designed and struck by Louis Comfort Tiffany of New York. This pen-and-ink rendition of the medal was made by one of the daughters of James Dickie, one of the gold-medal winners, who chose to purchase his award. (Courtesy of the Hampton Roads Naval Museum and the descendants of James Dickie.)

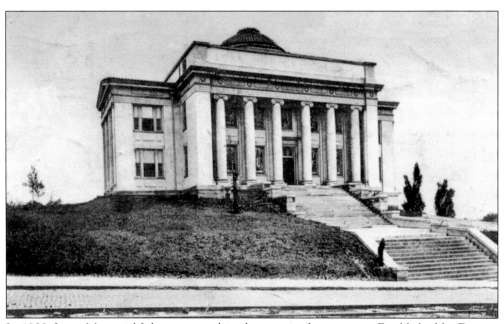

In 1908, Jones Memorial Library opened its doors to its first patrons. Established by Frances Watts Jones in memory of her husband, George Morgan Jones, a prominent businessman, it was a private facility, not a public one. It quickly became one of the most important genealogical libraries in Virginia. This postcard was printed shortly after the library opened. (Courtesy of the Potter Collection.)

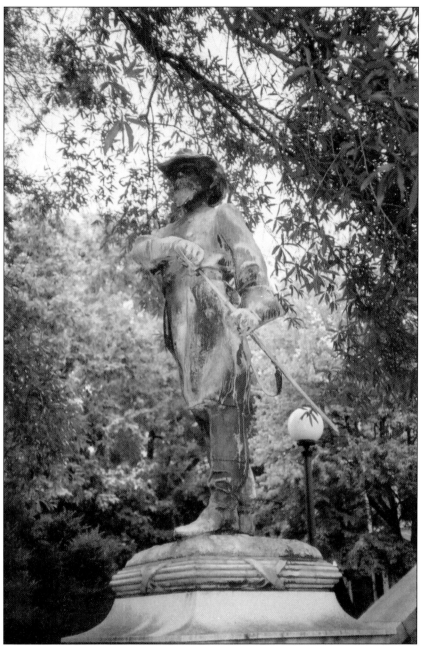

Frances Jones commissioned two identical bronze statues of her husband; one was to adorn the grounds of the library that bore his name, and the other one was to be placed on the campus of Randolph-Macon Woman's College. George Jones was an early and enthusiastic supporter of founding a college for women in Lynchburg. The statue by Solon Hannibal Borglum shows Jones in the accoutrements of a Confederate officer, though he never rose above the rank of private. His service in the 2nd Virginia Cavalry was brief because of his fragile health. The statues were unveiled in 1911, and each one was moved several times. The version at the library was sold a number of years ago, but Randolph-Macon's statue still guards the campus. (Photograph by Dorothy Potter, courtesy of R-MWC.)

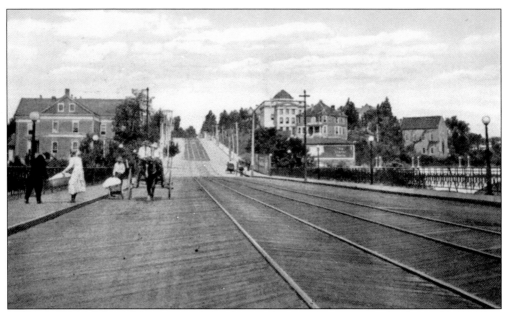

Patrons of Jones Memorial Library and residents of the north end of Lynchburg made use of an improved Rivermont Bridge. On the right side is Piedmont Business College, and to the left of the library is the original Holy Trinity Lutheran Church. This postcard is dated 1908 and is part of the series that included the new library. (Courtesy of the Potter Collection.)

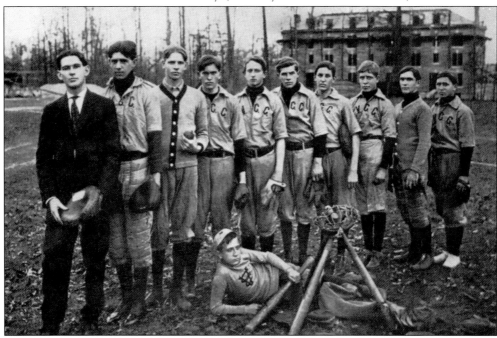

Men's baseball was the first intercollegiate sport played at Virginia Christian College (Lynchburg College), because Dr. Josephus Hopwood considered it "a manly Christian sport." The team cleared its playing field and sold the trees for firewood. With the funds, they purchased uniforms and equipment. In the background is Carnegie Hall, which was built in 1909—the only dormitory that Andrew Carnegie ever built. (Courtesy of Lynchburg College.)

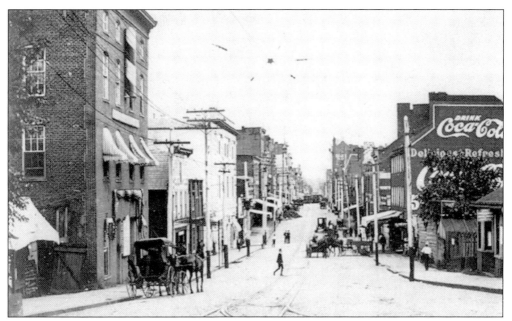

Adam Plecker made this photograph of Main Street from the corner of Fifth Street some time between the completion of the Academy of Music in 1905 and 1911, when a fire devastated the popular venue. The dark lines at the top of the photograph are not flaws on the negative, but the electric streetcar wires that were part of the cityscape until 1941. (Courtesy of Jones Memorial Library.)

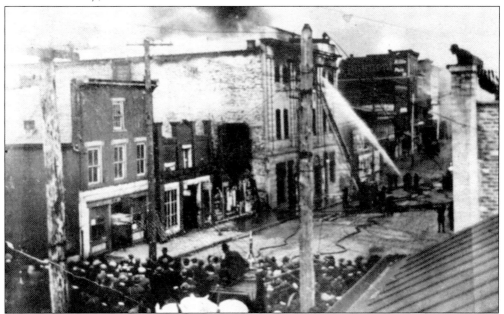

In 1911, a fire seriously damaged the Academy of Music at the corner of Sixth and Main Streets. The first all-electric public building in Lynchburg, the academy was soon refurbished in the popular Beaux-Arts style. Deep within the heart of the theater there was serious fire damage that would not be revealed until a wind storm struck the theater in 1993. (Courtesy of Jones Memorial Library.)

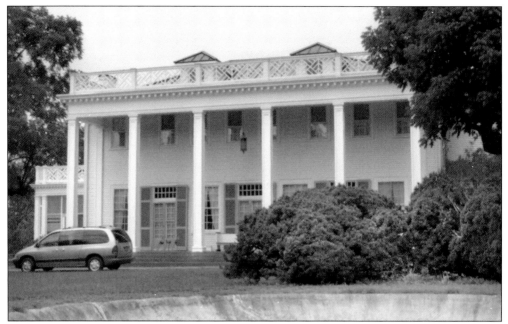

Although the number of spas in Virginia declined during the first quarter of the 1900s, Bedford Springs near New London in Campbell County remained a popular retreat. The spring water, rich in alum, was considered a restorative. The cottages have vanished, but the hotel—now a private home—remains. (Photograph by Randy Lichtenberger, courtesy of the Friends of New London, Virginia, Inc.)

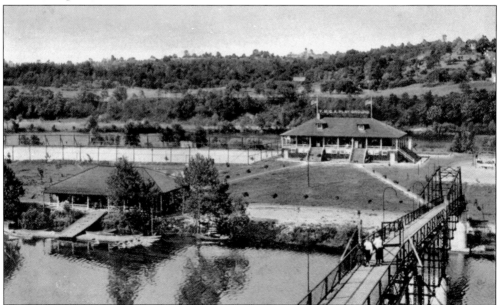

In June 1912, the YMCA Island Play Grounds on the James River was opened to the public. It provided boating and water sports as well as a clubhouse, tennis courts, a track, and baseball fields. It was opened in season on weekdays from 2:00 until 9:30—and until 11 on moonlit nights. Sunday hours were 2:00 until 6:30, but swimming was not permitted. (Courtesy of the Potter Collection.)

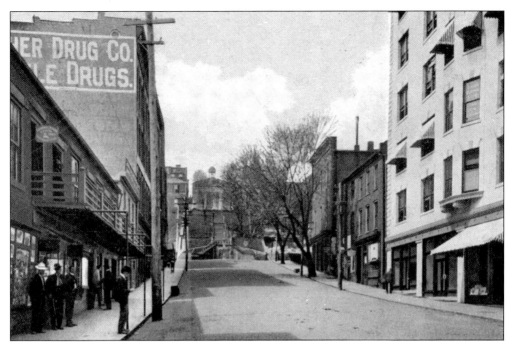

This photograph of Ninth Street was taken near the site of the old Market House. In the upper portion of the postcard is the firemen's fountain and the courthouse steps. In the right of the photograph is the edge of the Krise Building, completed in 1905. The American National Bank was located here at that time. (Courtesy of the Potter Collection.)

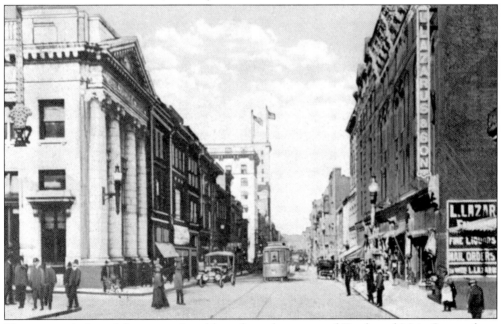

This postcard view of downtown Lynchburg from the corner of Tenth and Main Streets dates from the period shortly before America entered the First World War. In the foreground is the First National Bank, and in the upper left corner of the photograph is the Krise Building and the People's National Bank, which was completed in 1914. (Courtesy of the Potter Collection.)

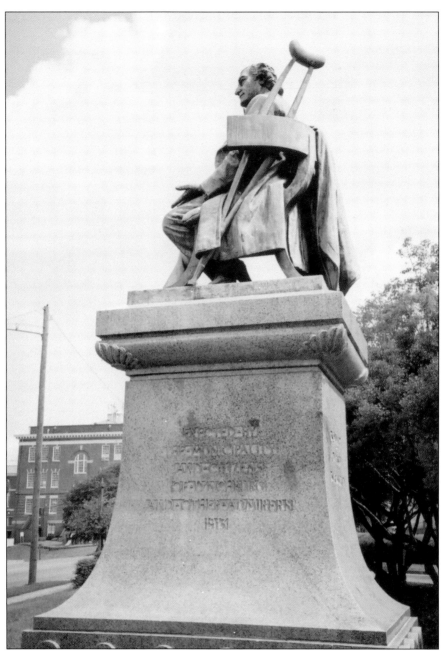

In 1913, the citizens of Lynchburg contributed generously to the purchase of a statue honoring the late senator from Virginia John Warwick Daniel, who died in 1910. The artist chosen to execute the commission was the expatriate Sir Moses Ezekiel. Both Daniel and Ezekiel had served in the Confederate army. While Daniel chose to continue fighting for the Lost Cause in the U.S. Congress, Ezekiel eventually settled in Rome. His works adorn the campus of the Virginia Military Institute and the University of Virginia as well as a number of public places, including Arlington National Cemetery. The statue of Senator Daniel was not unveiled until May 26, 1915, because of the outbreak of hostilities in Europe in August 1914. Although Italy did not enter the war on the side of the Allies until 1915, the shipment of the completed statue was delayed for a year.

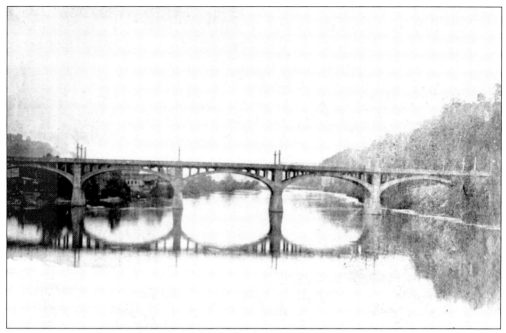

Between 1916 and 1918, the utilitarian iron bridge across the James River was replaced with the graceful Williams Viaduct. The old bridge, like its predecessor, gave access to downtown via Ninth Street. The new span used Fifth Street as its entry point, and thus relieved traffic congestion in the heart of the city's main commercial district. (Courtesy of the Potter Collection.)

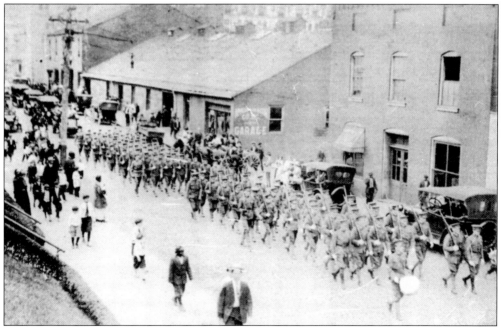

In April 1917, the United States declared war on imperial Germany, and within days of America's entry into the conflict, Lynchburgers began to volunteer for the various branches of the military. Marching along Commerce Street, this group of recruits makes its way to the Norfolk and Western railway station to embark for the nearest training camp. (Courtesy of Jones Memorial Library.)

Working with the American Red Cross, women of Lynchburg did their part in the Great War. As packed troop trains passed through the city bound for training camps and ports of embarkation, Lynchburg became "Lunchburg." The local chapter of the Red Cross supplemented the standard rations provided by the government with sandwiches, desserts, and fresh fruit, to the gratitude of the troops. This service was performed on a daily basis during the months of America's involvement in the war. Local housewives were supplied with the necessary ingredients, then they prepared the food each day, and a group of volunteers collected it and delivered the carefully packed bundles to the railway stations for distribution when the train made its regularly scheduled stops in the Hill City. (Courtesy of Jones Memorial Library.)

As the area beyond Rivermont Park began to develop, farmland gave way to suburbs. In the upper left-hand corner of this photograph is the site of the future Virginia Baptist Hospital. Oak Lane enters Rivermont Avenue at the edge of the hospital property. The ghost of the old Lexington Turnpike may be seen in the center of the picture. (Courtesy of the Design Group.)

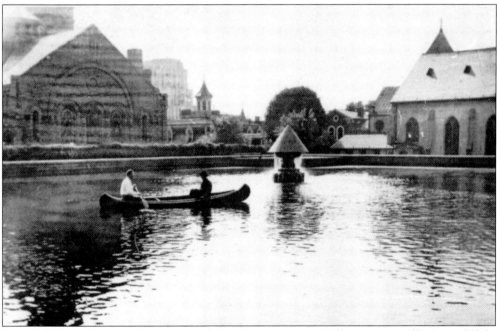

In the 1920s, pranks, from hanging porch furniture in trees at Halloween to swallowing goldfish, were a popular diversion. The two men in the canoe went over the ornate fence that protected the reservoir and placed their vessel in Lynchburg's drinking water while an accomplice took a photograph of their daylight voyage. (Courtesy of Jones Memorial Library.)

HOME
OF THE
PIEDMONT MOTOR CAR CO., Inc.

The present home of the Piedmont Motor Car Co., Inc., *and its product,* developed from an idea to a modern equipped plant with capacity of 2000 finished motor cars per annum. In January, 1917, the company moved into the first unit of its plant, and in March of that year turned out its first finished cars. Since then six additional units have been completed, giving an aggregate of 40,000 sq. ft. floor space. The last addition being one of the most modernly equipped body making plants in the country, with a capacity of 30 completed bodies a day.

6-40 CLUB ROADSTER

For 1918 the Company announces several new styles, consisting of Roadsters and Touring cars in both four and six cylinder models. These are of the latest design and in appearance and workmanship are surpassed by none.

No longer a stranger but a tried and tested friend with *Style, Comfort,* and above all *Durability,* built in every Piedmont.

Values offered in the cars shown here may seem too good to be true, but they are true and are made possible by close attention to every mechanical detail, careful buying and standardized production.

The enthusiastic welcome given the now popular 1917 Piedmont-30, is being repeated, and large orders are being booked daily.

The demand for the company's product is far in excess of the present production facilities and an increased capacity is being planned.

The Piedmont-30 five-passenger, announced a year ago was the sensation of the season and became instantly popular in the ten different states in which the entire first year's production was distributed.

4-30 TOURING

For Particulars, detailed specification price and terms on open territory, address

Piedmont Motor Car Co., Inc.
Lexington Turnpike and Southern Railway
LYNCHBURG, VA.

6-40 SPEEDSTER TOURING

Briefly in the early 1920s, Lynchburg was the site of the Piedmont Motor Car Company, Inc., which was located near the junction of Bedford Avenue and Hollins Mill Road. The company was founded in 1917 and closed its doors in 1923. In addition to the Piedmont, the firm built the Lone Star for a Texas concern, the Bush for a company in Chicago, and the Alsace for export abroad. The parts for these cars were not fabricated in Lynchburg but purchased from auto supply firms, and although the cars were assembled and painted in Lynchburg, they were much more expensive than automobiles produced in factories where the entire vehicle was fabricated under one roof. The Piedmont, although a quality product, cost four times as much as the comparable Ford-manufactured car. Because the company was short lived, the Piedmont has become one of the most valuable antique cars in existence. (Courtesy of the *Lynchburg News.*)

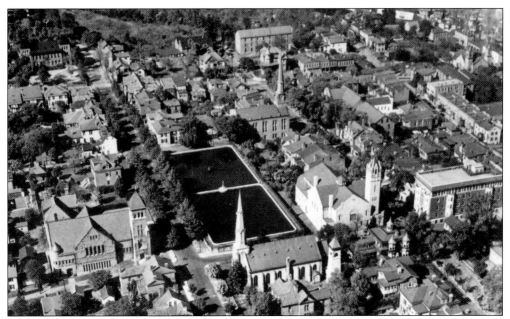

This aerial view of the area between Madison and Court Streets was part of a general survey made in the mid-1920s. In the center is the reservoir, but of particular interest are the five churches shown here. Moving clockwise from top are St. Paul's Episcopal Church, First Christian Church, Court Street Baptist Church, Court Street Methodist Church, and Holy Cross Catholic Church. (Courtesy of Jones Memorial Library.)

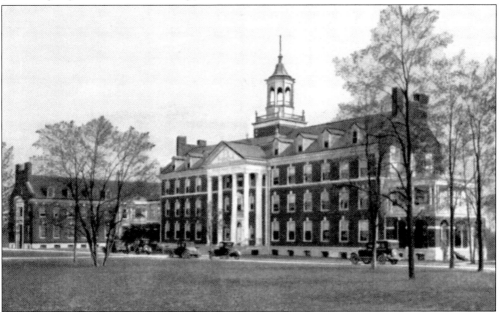

In 1924, Virginia Baptist Hospital opened its doors. It is located on a tract of land now bordered by Rivermont Avenue, Oak Lane, Vassar Street, and Rivermont Terrace. Over the years, there have been a number of additions to the plant, but the original design remains visible in its carefully planted and maintained park. Virginia Baptist is one of the finest facilities in Virginia. (Courtesy of the Potter Collection.)

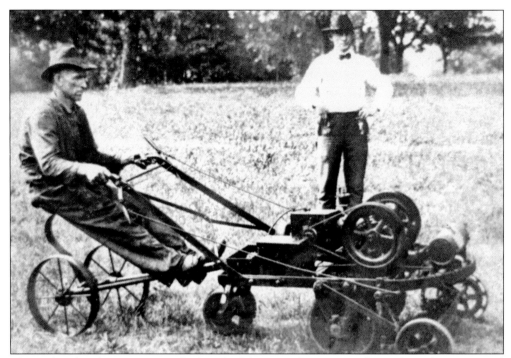

This early riding lawn mower made the job of the grounds crew at Miller Park much easier. Until the 1920s, all maintenance at the city's parks was done by hand, a daunting task as more land was converted to green space. Lynchburg has wisely preserved its green heart for the pleasure and recreation of its citizens. (Courtesy of Jones Memorial Library.)

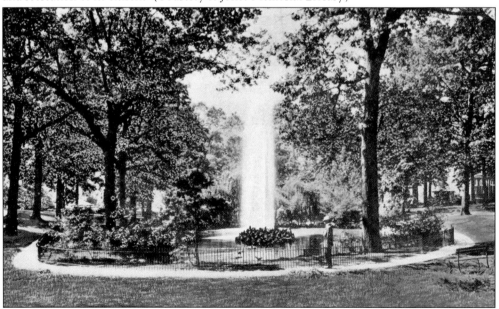

This postcard of the fountain and water garden at Miller Park was made before 1925, when Monument Terrace replaced the late-19th-century steps. The firemen's fountain was moved to Miller Park and placed in the middle of the water garden, where it remained until it was destroyed during Hurricane Hazel in 1954. (Courtesy of the Potter Collection.)

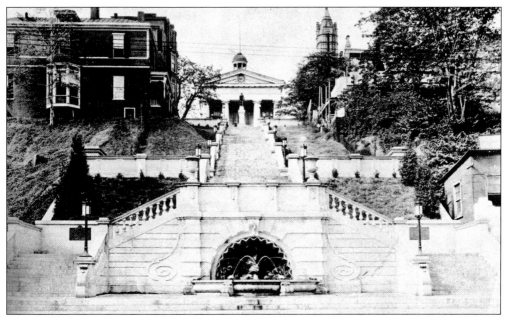

Built between 1924 and 1925, Aubrey Chesterman's Monument Terrace replaced August Forsberg's 1880s steps. The original design included a dolphin fountain and an ornamental basin resting on bronze turtles. The elegant fountain was replaced in 1926 by *The Listening Post*. Placed in storage for over half a century, the dolphin fountain is now the centerpiece of the refurbished City Market. (Courtesy of Jones Memorial Library.)

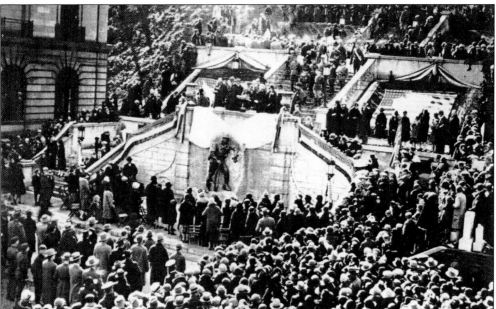

On November 11, 1926, Charles Keck's statue, *The Listening Post*, was unveiled and dedicated to the 43 men from Lynchburg who died in the Great War. Keck's heroic bronze transformed the elegant staircase that connects Court Street to Church Street into a true Monument Terrace. Keck designed three commemorative coins for the U.S. Mint, including one for Lynchburg. (Courtesy of the *Lynchburg News*.)

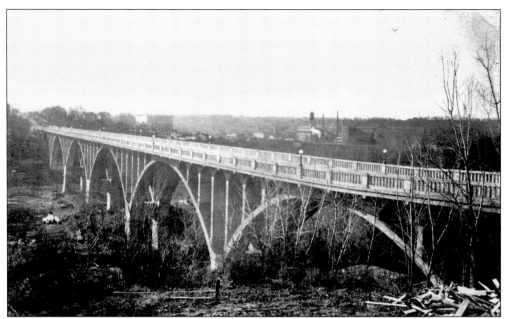

In 1925, it was decided to recondition Rivermont Bridge by encasing the iron structure in concrete. The process took a year. The span was further strengthened by the addition of two new arches. This remodeling was necessary because of the increased traffic and weight of the trolley cars. New lighting was installed and sidewalks paved. (Courtesy of the Potter Collection.)

Lynchburg has provided its citizens with professional police protection for two centuries. The leadership of the force has always sought to be on the cutting edge of law enforcement technology and crime fighting. As the horse-drawn era gave way to the squad car and the motorcycle, Lynchburg spared no expense to equip its officers with modern vehicles, as this photograph from the early 1930s illustrates. (Courtesy of Ronnie Tucker.)

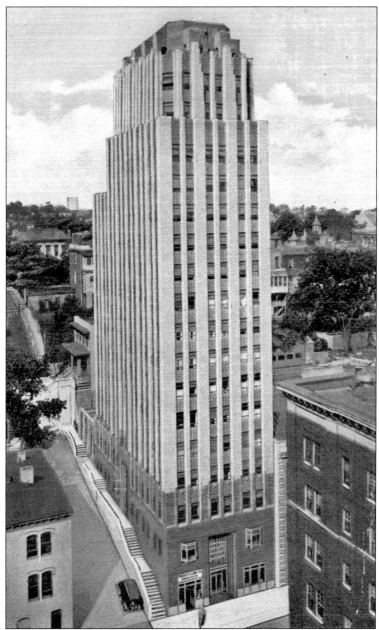

Just as America's economy began to sink into the Great Depression, Lynchburg's first skyscraper, the Allied Arts Building, began to rise on the corner of Eighth and Church Streets across the street from the Miller-Claytor House. Begun in 1929, the building was completed in 1931. Built in yellow brick and trimmed in local green stone, it was designed in the art deco style. Lynchburgers were so entranced by its decoration and height that they would find any excuse to ride its elevators to the top floor to peer through the windows at their city, the river, and the mountains. It was worth a visit to the dentist just to share the view. It became a center for healthcare professionals, whose offices had been scattered throughout downtown. The convenience of being able to visit the doctor, the dentist, and even the optometrist all in one building was opportune, especially during the war, when gasoline was rationed. (Courtesy of the Potter Collection.)

In the years before World War II, one of the most popular events in the spring was the Tulip Festival in Miller Park. Dressed in Dutch costumes, the hostesses gathered the blossoms. There was music and dancing, but it came to an end in 1942, when all available park land was converted to victory gardens. (Courtesy of Jones Memorial Library.)

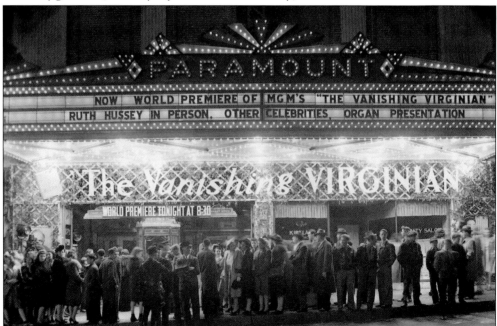

For one moment in January 1942, Lynchburg was able to forget the war and enjoy the world premier of *The Vanishing Virginian*, based on Rebecca Yancey Williams's memoir of her father, Robert D. Yancey, the longtime Commonwealth's attorney of Lynchburg. The premier was held at the Paramount Theater, the city's newest movie palace. (Courtesy of the S. O. Fisher Collection.)

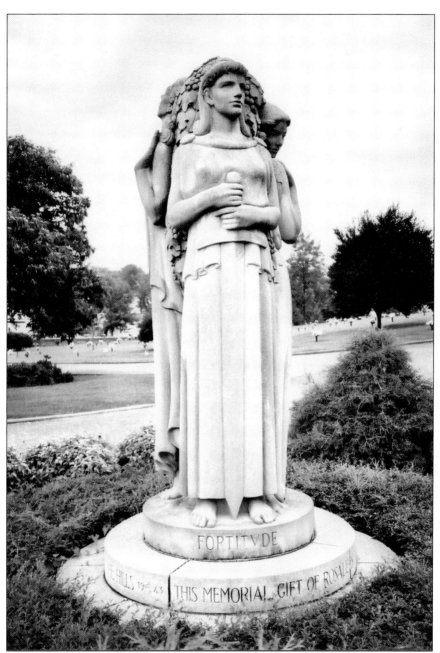

Dr. Rosalie Slaughter Morton gave an unusual piece of sculpture designed by Brenda Putnam to Spring Hill Cemetery in 1943. The three cast concrete figures represent vision, fortitude, and kindliness. The dedication reads "This Memorial Gift . . . is a Tribute to the Sons & Daughters of Our City of the Hills 1943." By the time of its dedication, the list of local service men and women wounded or killed in the Pacific and European theaters was already quite long. Lynchburg's draft board did not have to exert its authority during the early months of the conflict, because their quotas were met by volunteers. It was not uncommon for those anxious to fight for their country to either add or subtract a few years to be eligible. Lynchburg also became a liberty town for service men and women stationed in nearby camps.

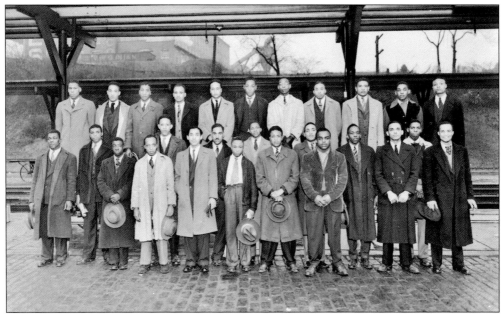

This group of black draftees was photographed in 1943 at the Southern Railway station before they departed for boot camp. All of the services were segregated until 1948, but black soldiers were still expected to answer their country's call. Often they had to fight the military bureaucracy in order to see real combat and not be permanently assigned to support services. (Courtesy of the *Lynchburg News*.)

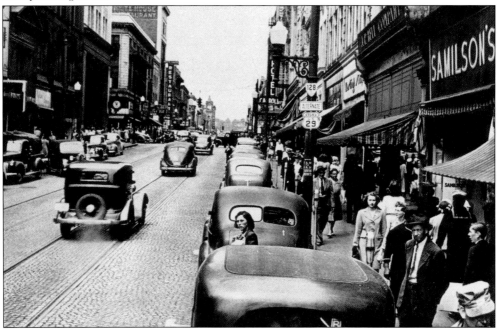

In the spring of 1945, the war was drawing to a close in Europe, and life began to return to normal in Lynchburg. Soon rationing would end, and before Christmas, the veterans would return home. This photograph was taken near the corner of Ninth and Main Streets at lunchtime. (Courtesy of Jones Memorial Library.)

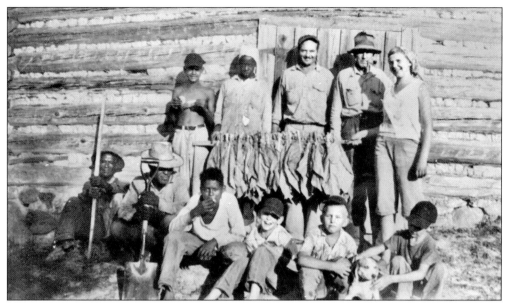

In the 1950s, tobacco remained the most important cash crop grown in Central Virginia, and the keening of the tobacco auctioneer still echoed in Lynchburg's remaining tobacco warehouses. Leonard Dickerson and his daughter, Sue, stand with their workers after the end of another successful harvest of the golden leaf in Campbell County. (Courtesy of Ronnie Tucker.)

The Lynchburg Department of Parks and Recreation provides guidance as well as access to facilities and equipment for any number of athletic teams of all ages. This photograph of the Miller Park football team—part of the city league—was taken c. 1948. Many of these youngsters played for E. C. Glass during their high school careers. (Courtesy of the Department of Parks and Recreation.)

In September 1953, the new E. C. Glass High School opened. Located on a large tract of land on Memorial Avenue (now Martin Luther King Boulevard), it housed grades 8 through 12. The site was part of the old fairgrounds, and part of the campus contained the city's Union POW camp between 1861 and 1865.

In 1956, a young Baptist minister, Jerry Falwell, started a new church in a deserted bottling plant on Thomas Road. Understanding the potential of television, Falwell soon transformed his tiny church into the phenomenon that has become Falwell Ministries.

Five

A SEAT OF LEARNING
1957–2007

Diversity—economic, racial, educational, and cultural—thrives in Lynchburg. Just as the city's architecture encompasses varied styles, so the community has many facets.

Local Jewish-Christian relations have a long history. For example, in 1935 Lynchburg College was the site of Virginia's first chapter of the National Conference for Christians and Jews (currently the National Conference for Community and Justice). However, mid-century Lynchburg was not a beacon of racial equality, despite voices for change like Rev. Beverly Cosby of the Church of the Covenant and students from Virginia Seminary and College, Lynchburg College, and Randolph-Macon (now Randolph College), who led a December 1960 sit-in at a downtown lunch counter. Change came gradually through dialogue, education, and new industries that brought in citizens with different points of view.

E. C. Glass High School opened its doors to African Americans in January 1962. Two months later, Dr. Martin Luther King Jr. spoke to an integrated audience in the school's auditorium. His memory is preserved in the Dr. Martin Luther King Center for Human Rights at the Lynchburg Public Library and Martin Luther King Boulevard beside it.

In 1976 and 1986, Lynchburg celebrated the nation's founding and the 200th anniversary of its incorporation. With the celebrations came preservation efforts including restoration of the Dolphin and Fireman's fountains, Monument Terrace (completed 2005), new tributes to soldiers from World War II, Korea, and Vietnam, and a memorial to POWs and those missing in action.

As the 21st century dawned, the celebration of our diverse history accelerated, including Civil War Days at Historic Sandusky, the Legacy Museum of African American History, and the adjacent Old City Cemetery. Nearby Jefferson's Poplar Forest and the National D-Day Museum in Bedford illustrate vision and sacrifice. Older colleges celebrated birthdays, new colleges were founded, and other, local restorations are on-going. In 2005, the area's Monacans were recognized with the naming of a new bridge—symbolic of what may be accomplished by all who call the area home.

The congregation of Agudath Sholom Synagogue was founded in 1897 and moved into its present building in 1957. The synagogue sits close to the remnants of the breastworks of Fort McCausland, one of the most important parts of General Early's plan for the protection of Lynchburg in June 1864.

This bronze plaque is in the center of the Fellowship Circle on the campus of Lynchburg College. On this spot in 1935, the first Virginia chapter of the National Conference of Christians and Jews was founded. Lynchburg chose to take a stand against ethnic prejudice the same year that the Nuremberg Laws robbed German Jews of their civil rights.

Built in 1962, the Lynchburg Fine Arts Center was home to all the arts in the city until its demolition in 2004. The center then merged with the Academy of Music to form the Academy of Fine Arts, headquartered on Main Street. The mission of the new organization remains the same: to enrich the life of each citizen through the arts. (Courtesy of the Potter Collection.)

The Academy of Music Theatre was a venue for live performance until the advent of sound motion pictures in 1927. Until 1958, it was a movie house. Saved from demolition in 1972, it's in the process of being restored to its Beaux-Arts grandeur. It is now the home of the Academy of Fine Arts.

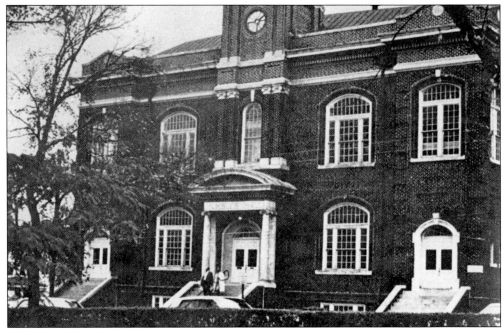

Humbles Hall, now renamed Graham Hall, is the oldest building on the campus of the Virginia University of Lynchburg, the oldest institution of higher learning in the city. It offers a number of programs, ranging from a certificate in ministry to a Doctor of Ministry. (Courtesy of Jones Memorial Library.)

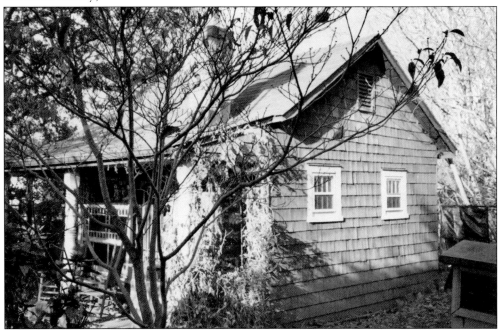

Perhaps the most famous graduate of Virginia Seminary and College (Virginia University of Lynchburg) is Anne Spencer, one of the leading poets of the Harlem Renaissance. Spencer worked in a cottage she named Edenkraal built by her husband, Edward, behind her house on Piece Street. Edankraal stands in the midst of her garden.

Begun in 1973, the Virginia Ten Miler is one of the premier races in the state, attracting runners from all over the world. The race begins and ends close to *Olympic Runner*, a sculpture by Umaña. It was dedicated at E. C. Glass High School in 1994. Runners practice all year for the grueling course that traverses some of the famous hills of Lynchburg.

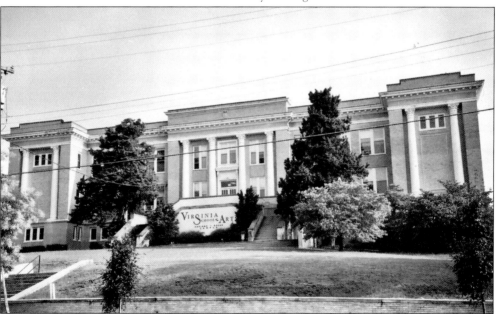

Located in the old Garland-Rodes School, the Virginia School of the Arts, founded in 1986, is one of Lynchburg's "gems." Students from all over the world gravitate to the great grey building on Rivermont Avenue. Graduates of VSA are members of some of the most prestigious ballet companies in the nation. Each year, the students give several recitals that have become local social events.

In 1976, when the dolphin from the fountain at the base of Monument Terrace was discovered in storage, the Lynchburg Woman's Club adopted its restoration as its National Bicentennial Project. It now forms the centerpiece of the bricked piazza at the Lynchburg City Market. Its basin glistens with coins thrown by shoppers, and these bits of change are donated to local charities.

While Lynchburg did not celebrate the nation's centennial in 1876, in 1976 it threw a gala party. One of the events was a costume contest, and it was amazing how many people arrived at Miller Park in Colonial dress. Here are a few of the contestants in their finery. While the weather was cloudy, it did not dampen the spirits of the participants.

Each year as part of the Kaleidoscope Festival, Day in the Park attracts children of all ages. Here Dr. John Harris, a piper from Roanoke, entertains a group of local Girl Scouts. History is mixed with fun on this special Saturday in September, and booths offer culinary delights from around the world.

In June when the bateaux race to Richmond begins, there is a festival by the James River. It attracts craftsmen and musicians from all over the East Coast. Lynchburg's Parks and Recreation Department plays an important role in making every local festival a success. Here Mozart lends his music to making the day perfect.

Virginia Episcopal School was founded in 1914. This photograph was taken on graduation day 1987, the academic year the school became coeducational. In the two decades since women joined the alumni association, they have made contributions of excellence in every field.

Leading the procession on graduation day at Lynchburg College is Dr. Thomas C. Tiller Jr., the college marshal. He carries the college mace, carved from a beam from Westover Hall, the original college building demolished in 1970. The mace was designed by Prof. Clifton W. Potter Jr. and fashioned by Prof. Richard G. Pumphrey.

The J. W. Wood Wholesale Grocery building has been transformed into Amazement Square. This has been a major project of the Junior League of Lynchburg, and the results of their efforts are absolutely stunning. Adults are able to enjoy the interactive exhibits almost as much as the children for whom they were designed.

In an effort to improve the appearance of deserted buildings in downtown Lynchburg slated for restoration, Lynch's Landing sponsored the "Mural Arts Program." This painting in the window of the old James T. Davis building on Main Street celebrated the bateaux against a composite Lynchburg skyline.

Despite fears of massive computer failures and a run on bottled water, Lynchburgers gathered in local restaurants and at parties all over the city to celebrate New Year's Eve 1999. Dorothy Turner and her daughter, Dr. Dorothy-Bundy Potter, greeted 2000 at Meriwether's Market Restaurant. Theodore Roosevelt was the president of the United States when Mrs. Turner was born. At a time when Y-2K was the obsession of the national media, one local wit remarked that he had solved the problem by moving the date on his computer to 1949, since Lynchburg was 50 years behind the times anyway. While this might have been the case in 1949, it was certainly not so in 1999. The arrival of several new industries in the 1950s had transformed Lynchburg into a thriving, modern community. (Photograph by Edmund Potter.)

In 1993, the Dr. Martin Luther King Center for Human Rights was dedicated at the Lynchburg Public Library. The bust of Dr. King is the work of local sculptor Richard G. Pumphrey. In 1962, Dr. King spoke at E. C. Glass Auditorium, just a few yards from the center and on the street that now bears his name.

The Legacy Museum of African American History of Lynchburg and Central Virginia opened its doors to the public in 2000. The museum sponsors exhibits on a rotating basis emphasizing the African American experience from the African Diaspora until the present. It has proven a valuable teaching tool for schools in the Central Virginia area.

Dedicated on June 5, 2001, the National D-Day Memorial in Bedford commemorates the sacrifices made by the Allied forces as they launched their invasion of Hitler's Fortress Europe and especially the casualties suffered by the city of Bedford. It lost more men per capita when the first soldiers hit the beaches of Normandy than any other community in the United States. (Photograph by Virginia G. Ferrell.)

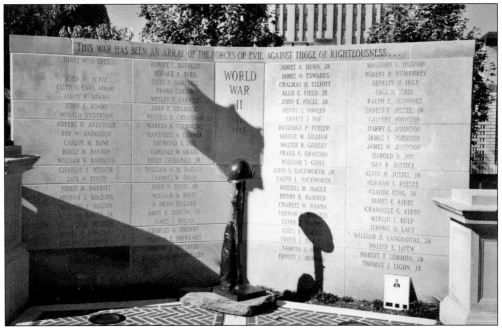

In 1986, as part of the city's celebration of the bicentennial of its incorporation, memorials were placed on the remaining levels of Monument Terrace. The dead from World War II are remembered with plaques and mementos covering both walls of the second level. As the hours pass, the sun casts sharp shadows across its surface—it is truly moving.

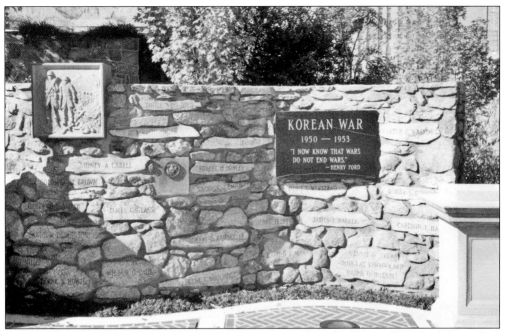

Moving up Monument Terrace, one reaches the memorial to the Korean War dead. Its surface is rough like the terrain in which the troops of the United Nations fought from 1950 until the truce was signed in 1953. The wall is curved, thus casting strange shadows.

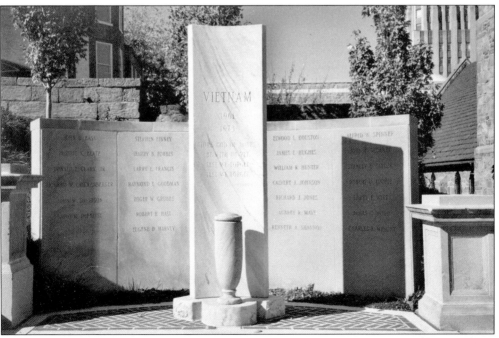

On the next level is the memorial to the casualties of the Vietnam War from Lynchburg. Its lines are clean, almost elegant—a stark contrast to the war that has left deep wounds in the national psyche. Another monument memorializes the prisoners of war and those missing in action.

The Lewis and Clark Corps of Discovery II came to Lynchburg in February 2003 at the beginning of its long journey to the Pacific Ocean. Despite snow and mud, the tent was full of Lynchburgers eager to learn more about the historically significant purchase of the vast Louisiana Territory from France in 1803.

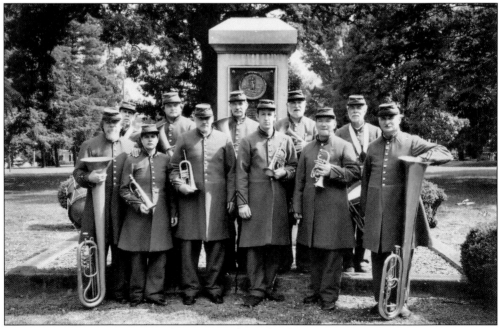

On June 19, 2005, as part of Civil War Days, the Federal City Brass Band gave two concerts, one at Historic Sandusky and one in Miller Park. For the latter performance, they donned Confederate uniforms and played as the 26th North Carolina Regimental Band. Civil War Days has become an important part of the city's summer festivities.

Founded in 1966, Central Virginia Community College has become an essential part of the higher education community in Central Virginia. Its programs have grown over the last four decades to serve a variety of needs. Its campus has a serene beauty that belies the fact that it is only a few hundred yards from one of the busiest roads in the city.

In 2003, Lynchburg College celebrated the 100th anniversary of its founding. Two years later, the dedication of Centennial Hall was held. It is the home of the School of Business and Economics and the Department of Communications. Filled with state-of-the-art technological equipment, it also houses an intimate concert venue, Sydnor Performance Hall.

One of the most interesting exercises for tourists and residents alike is to walk down Main Street. While many storefronts have been modernized, the upper floors remain untouched. This photograph shows a dramatic instance of this phenomenon in the juxtaposition of an ornate structure from the late 1800s with the starkly modern Bank of the James building. The corner of Ninth and Main Streets has seen a great deal of history in the last 250 years. Many of the most important events that have made this community what it is today have occurred where these streets intersect. This corner is also at the core of a successful project to restore and beautify downtown.

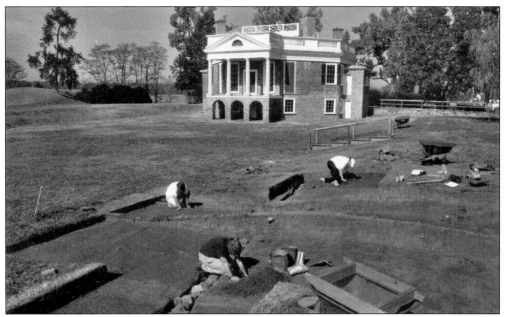

As Jefferson's Poplar Forest is carefully restored to its original, 1806 plans, the meticulous and often back-breaking work of the archeological staff continues. Each season they discover marvelous things that deepen our knowledge of the 19th century, the mind of Jefferson, and the history of Central Virginia. The country retreat of our third president is one of the area's treasures. (Photograph by Les Schofer, courtesy of Thomas Jefferson's Poplar Forest.)

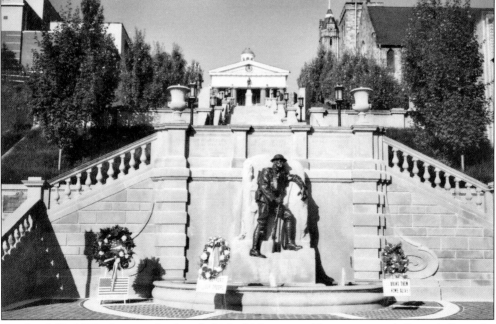

On April 30, 2005, the completely refurbished Monument Terrace was rededicated. Over the years, Lynchburg's signature had been slipping down the hill, so it was necessary to stabilize and preserve it for the new century. *The Listening Post* was also carefully cleaned and a fountain added at its base, echoing the original design of Aubrey Chesterman.

As his Eagle Scout project, Joey Ricketts chose to honor the memory of those Americans who died on September 11, 2001, at the Pentagon, and especially Col. David Scales, whose father is a member of American Legion Post 16. The granite pedestal is surmounted by a piece of limestone from the ruins of the section of the Pentagon hit by Flight 77. Several bronze plaques are attached to the main body of the monument detailing the tragic events of that day. It took two years for Joey to plan his project, raise the necessary funds, secure the materials, organize the work schedule, and see it through to a successful conclusion. In particular, the help of Michael Baer of Baer and Sons Memorials of Lynchburg proved crucial. The interior of the pedestal also contains a piece of the Pentagon. Lynchburg's newest memorial is in a sense its most poignant because it commemorates a tragedy on American soil.

The Arthur S. DeMoss Center at Liberty University is the largest academic facility in Virginia. It contains a bookstore, computer labs, dining facilities, dormitory rooms, classrooms, and a student center. In this sense, it closely resembles Westover Hall, the original building on the Lynchburg College campus—it too was a multi-purpose facility.

To celebrate its golden anniversary in 2006, Thomas Road Baptist Church moved to a new complex close to the campus of Liberty University. Because of the nature of the Falwell Ministries, the new facility is equipped with the latest technological equipment. It is also large enough to accommodate the regular members of the congregation as well as the thousands of visitors who attend services each year.

In the fall of 2006, the American Academy of Civil War Medicine held its national meeting in Lynchburg. In addition to sessions devoted to the reading of scholarly papers, the participants had the chance to explore Civil War Lynchburg. Their first stop was Historic Sandusky, where this authentic reconstruction of a Civil War–era ambulance was on display. They also visited the South River Meeting House, where the Battle of Lynchburg began; Fort Early; the remaining Civil War hospitals; the site of the transportation hub of Civil War Lynchburg; and finally the Confederate section and the Pest House Museum at the Old City Cemetery. (Photograph by Dorothy Potter, courtesy of Historic Sandusky.)

At the end of October 2006, the Old City Cemetery celebrated its bicentennial with an elaborate funeral parade honoring all those who rest within its walls. The procession was led by Blind Billy and the Lynch family. A time capsule was placed in the columbarium under the cemetery chapel, and there were refreshments and music for all the participants. (Photograph by Dorothy Potter, Courtesy of the Southern Memorial Association.)

Since the ferry was established, 250 years have passed, and on the eve of 2007, we return to the James River and to the Monacan tribe. The bridge named in their honor and blessed with their presence at the dedication serves as a symbol of what may be accomplished in the years that lie before the citizens of Lynchburg.

www.arcadiapublishing.com

Discover books about the town where you grew up, the cities where your friends and families live, the town where your parents met, or even that retirement spot you've been dreaming about. Our Web site provides history lovers with exclusive deals, advanced notification about new titles, e-mail alerts of author events, and much more.

Find *Your* Place in History.